Adult Colouring Book - Volume 8

Original & Unique
Mandalas for Mindfulness
&
Colouring Relaxation

by Charlotte George

Published in UK by: Charlotte George
© Copyright 2016 – Charlotte George

ALL RIGHTS RESERVED. No part of this publication may be reproduced or transmitted in any form whatsoever, electronic, or mechanical, including photocopying, recording, or by any informational storage or retrieval system except for the personal use of the purchaser or for group activities.

Getting Started

This is volume 8 in my Adult Colouring Book Series and I hope you will continue to enjoy colouring these new and original beautiful Mandalas as much as I have enjoyed creating them.

There are a few different levels of colouring for you to choose from depending on your mood. They are all mixed together so you can decide what level you enjoy colouring best and go from there. Whichever of them you decide to do, just enjoy your time colouring and have some fun.

I have been working on new design pattern books and journals but I always return to my first love of creating and colouring Mandalas which I really enjoy.

There will be lots of exciting patterns on some of my favourite themes so check out my website:
https://charlottegeorgecolouring.com

Happy Colouring

Charlotte

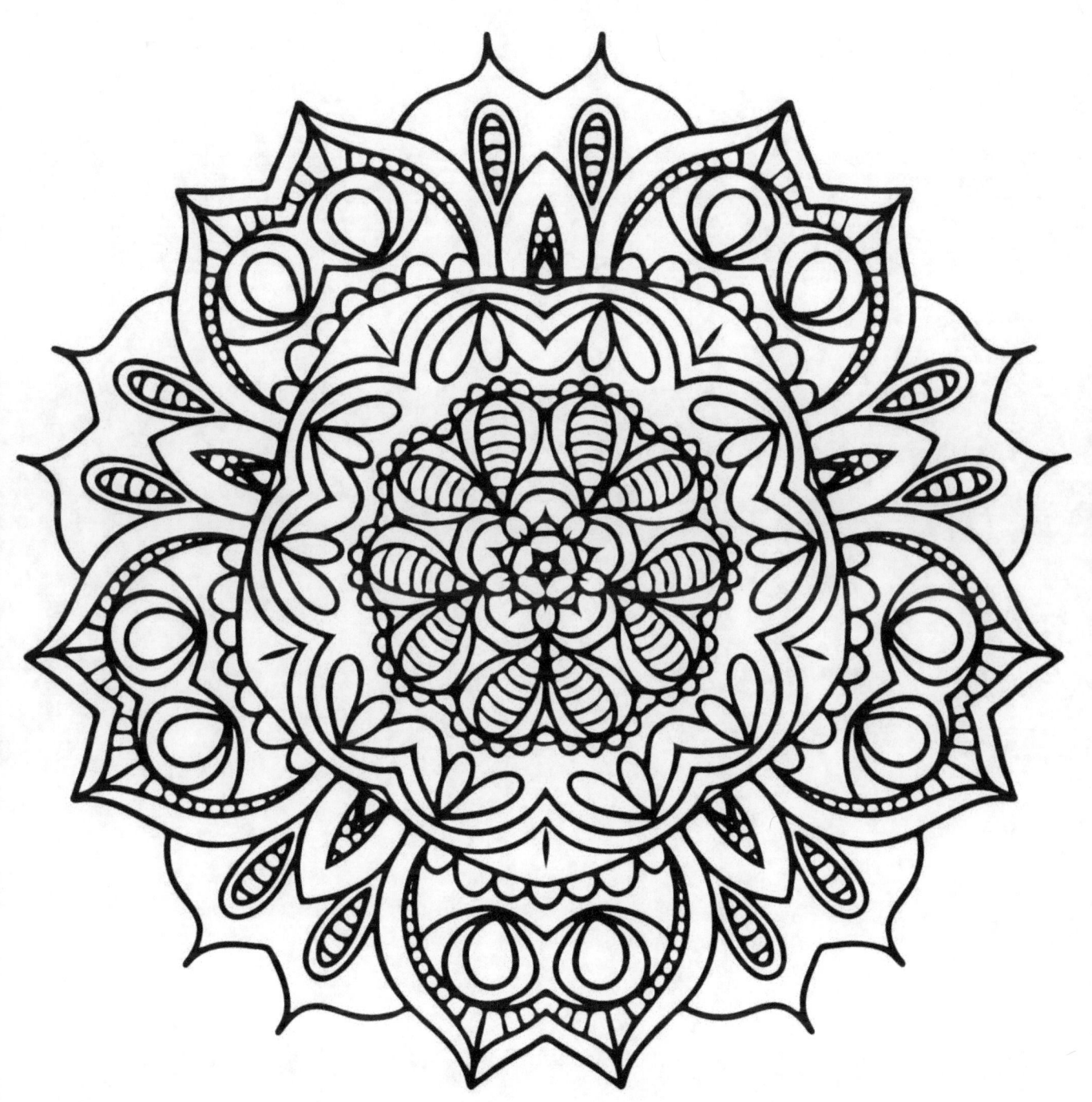

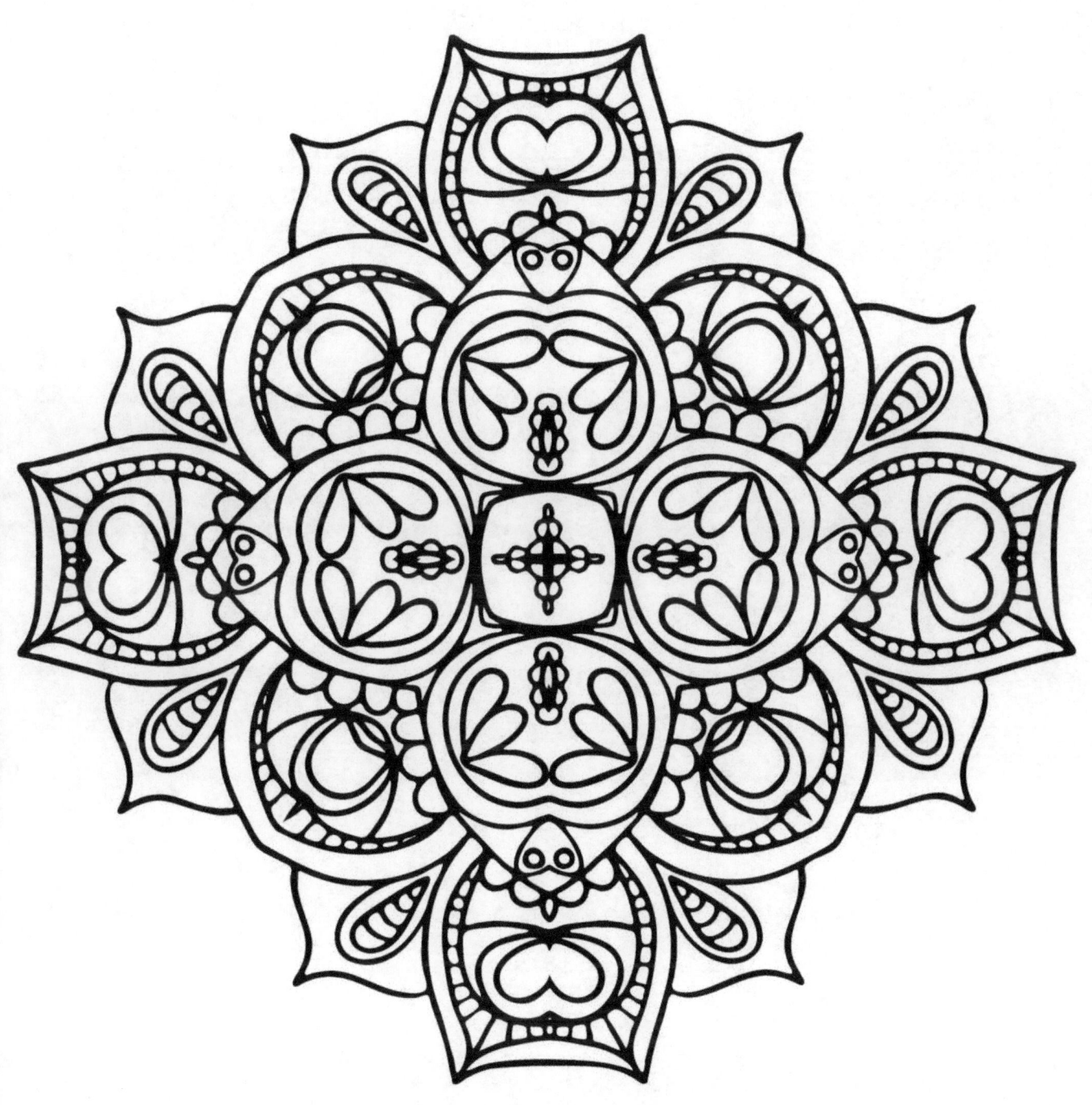

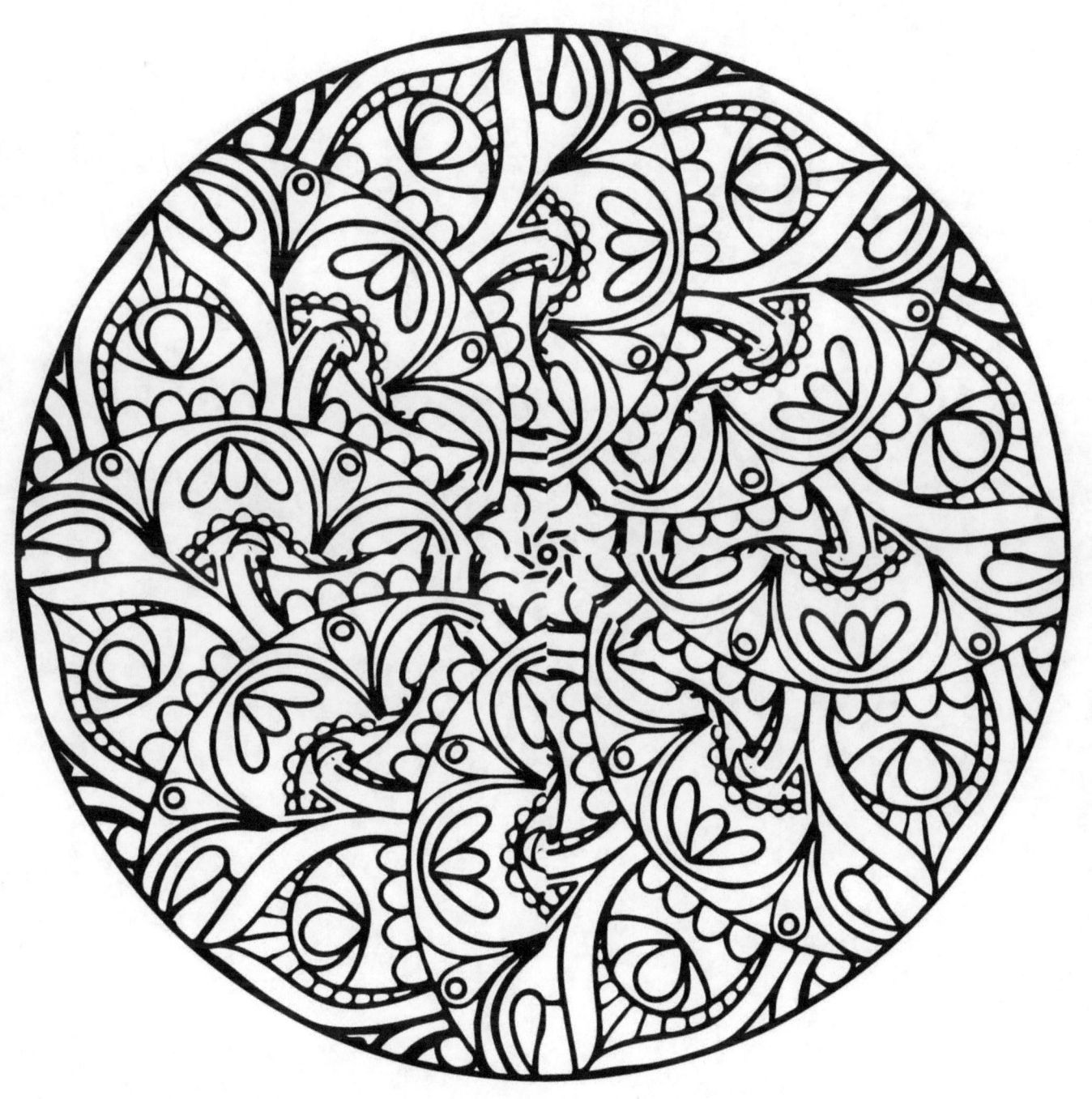

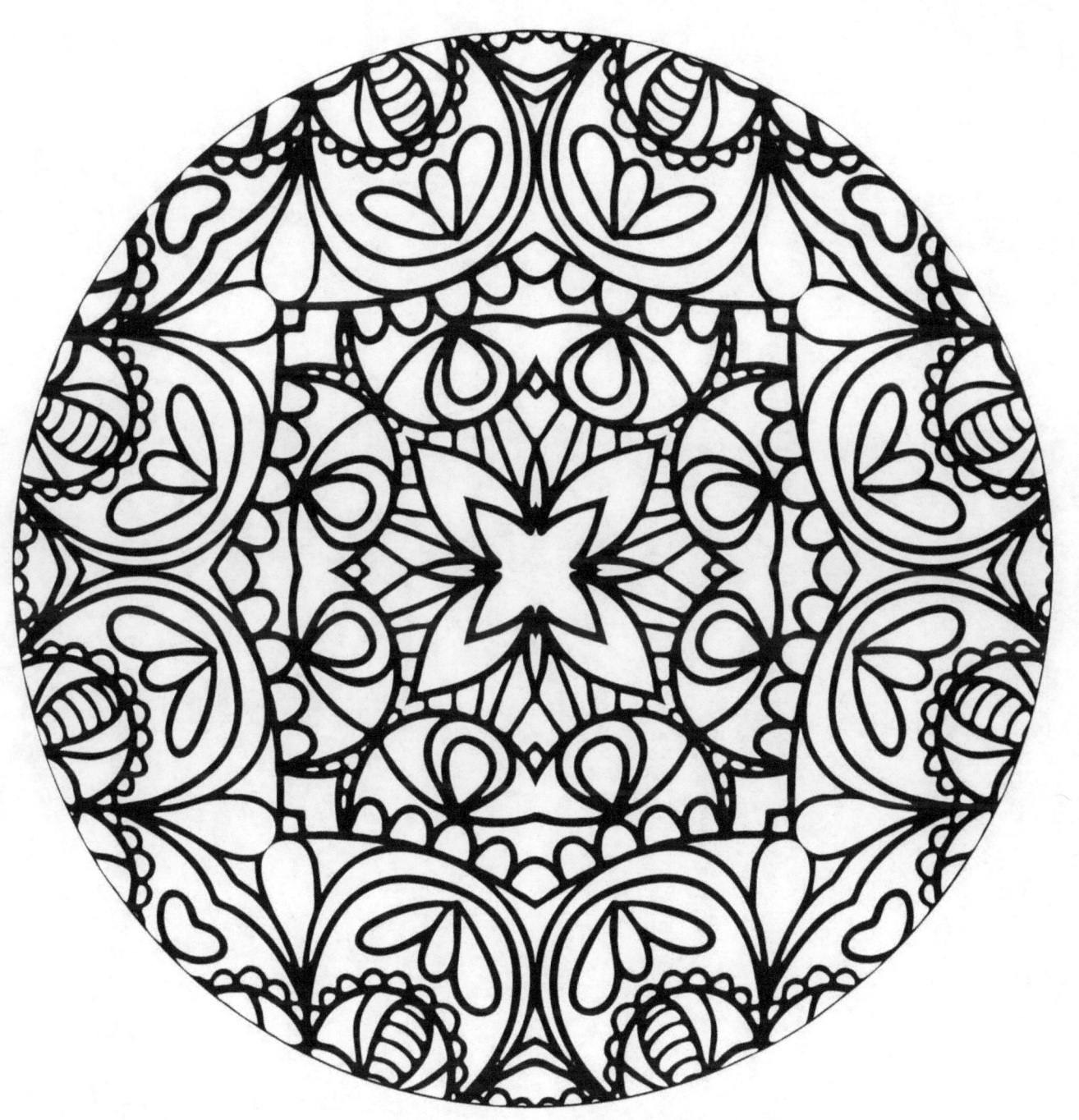

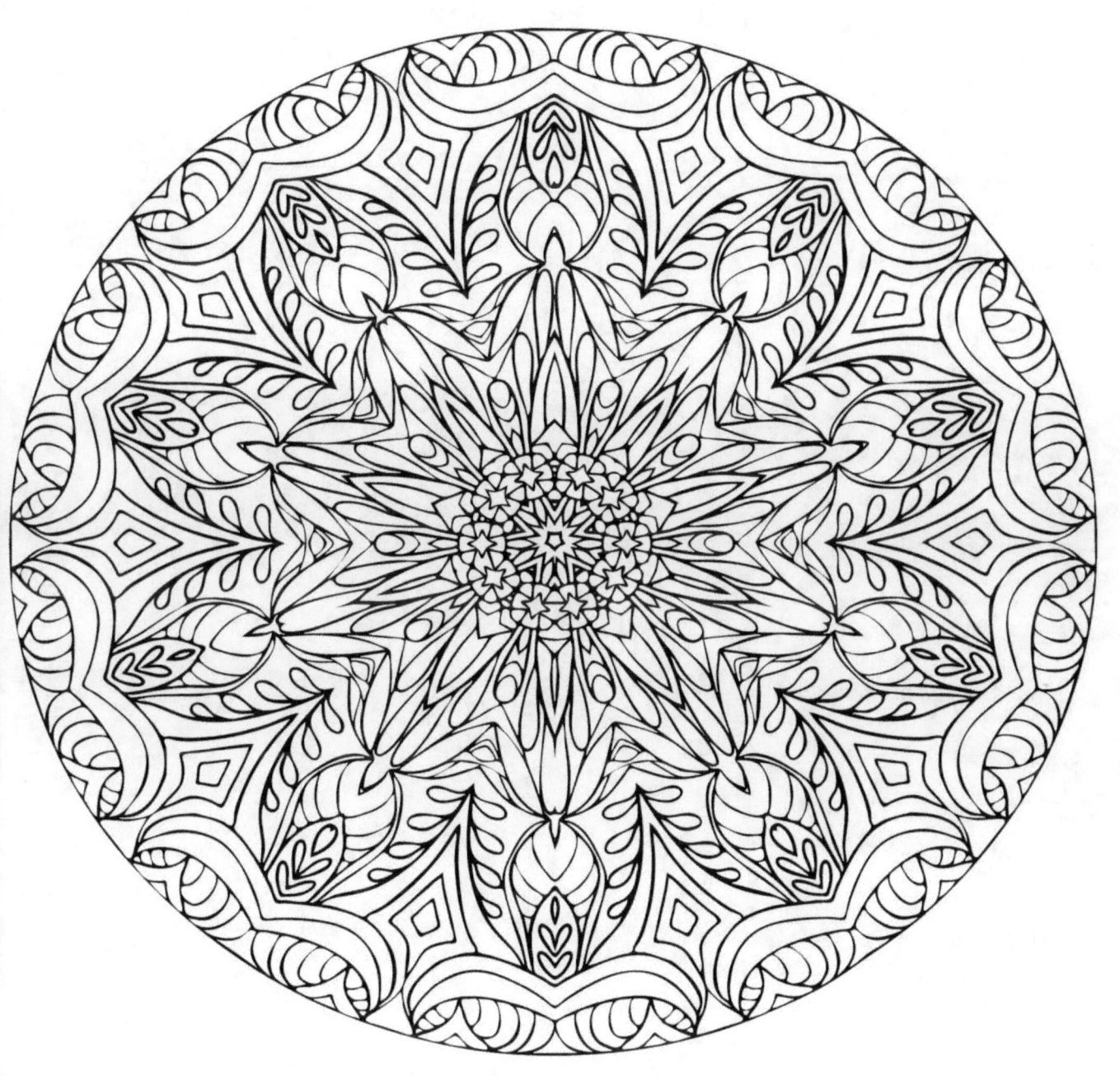

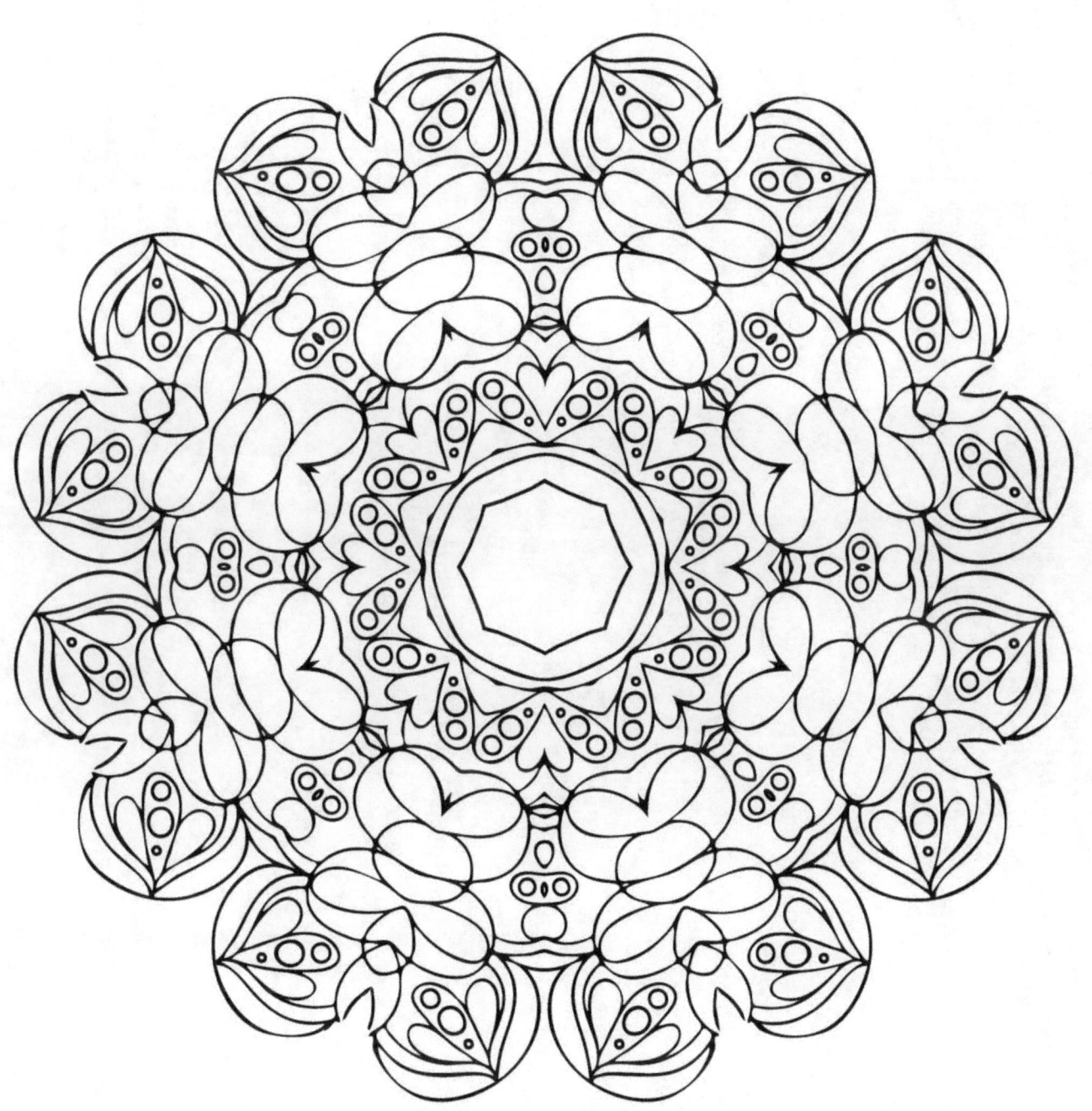

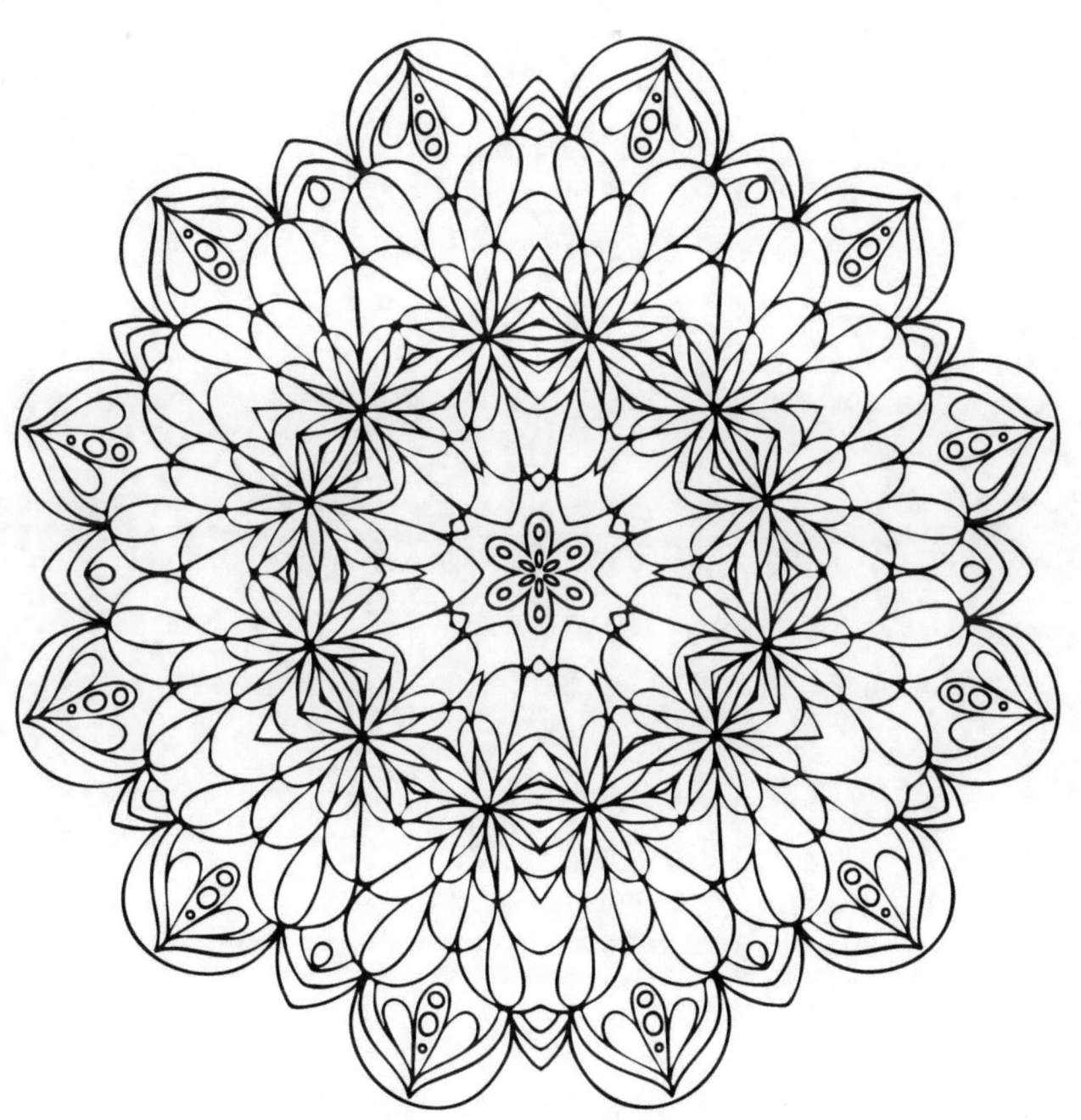

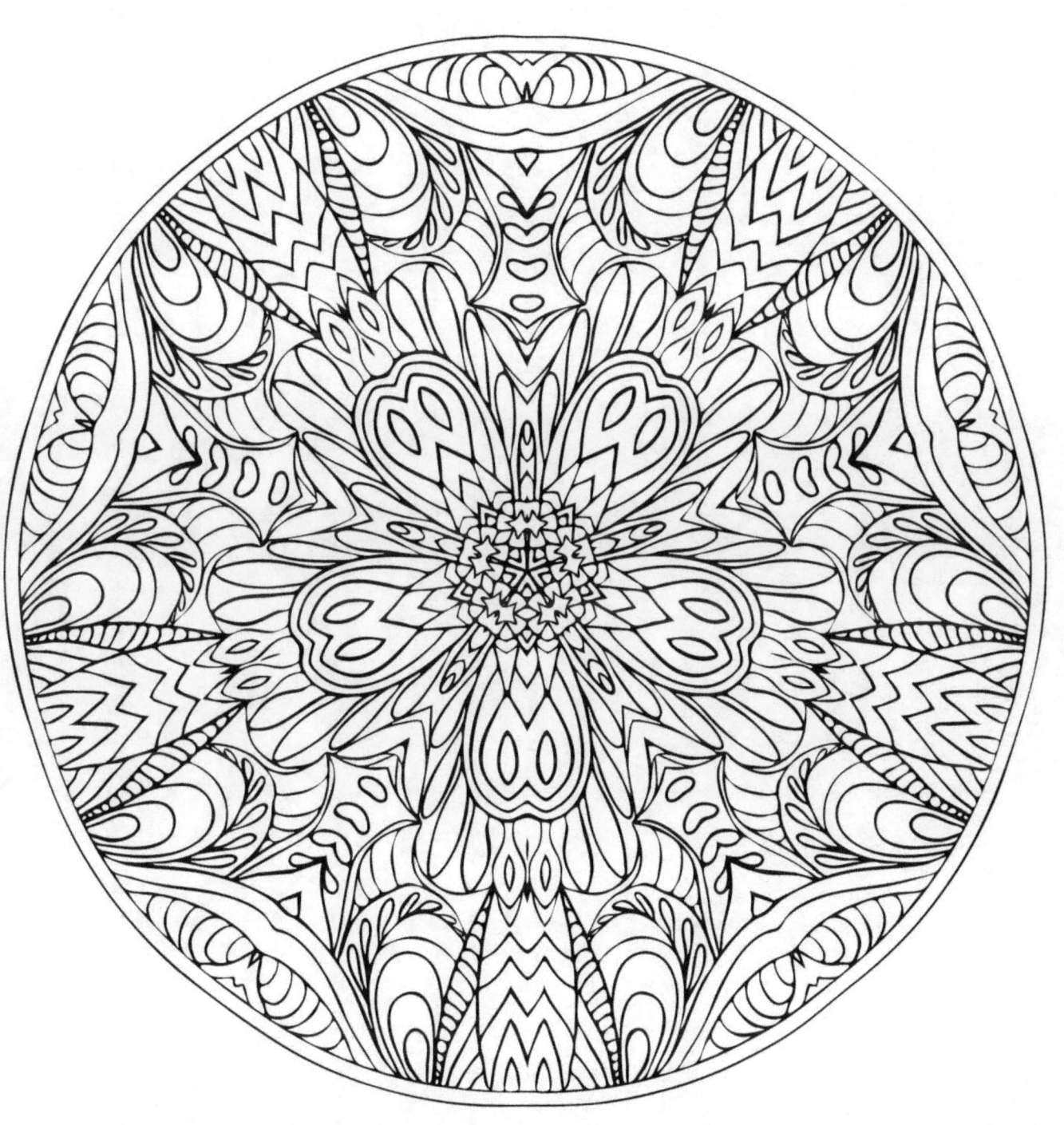

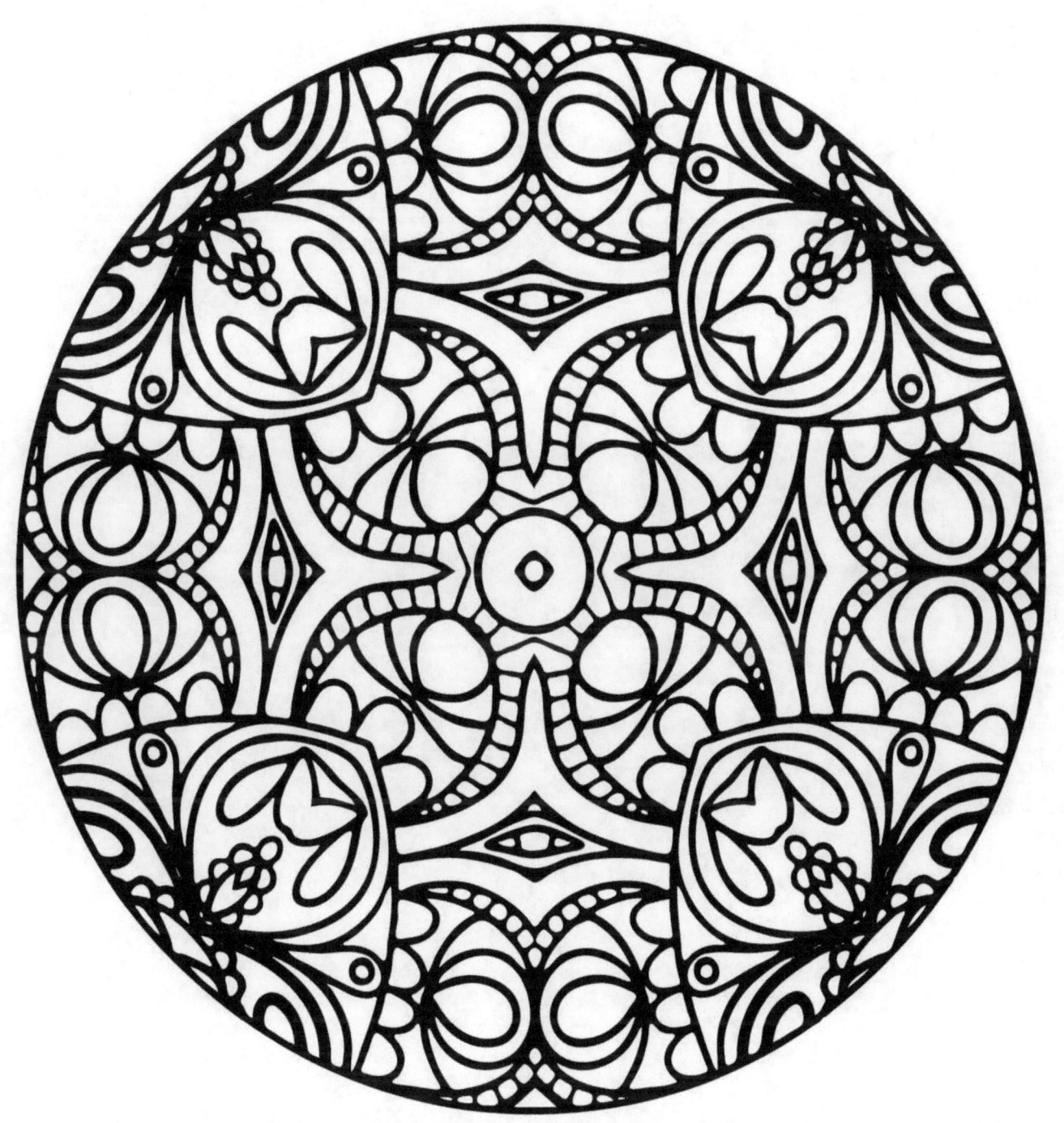

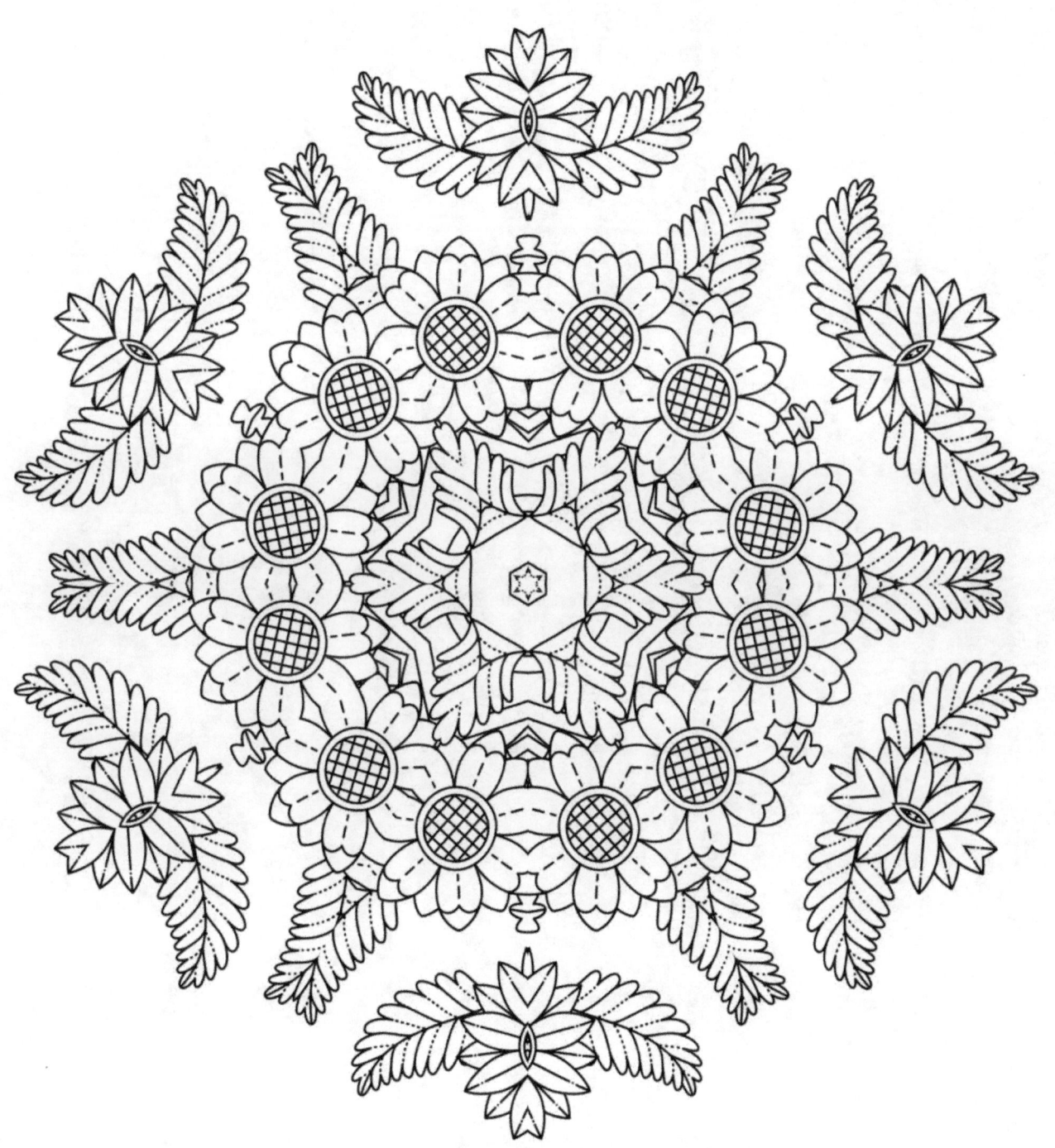

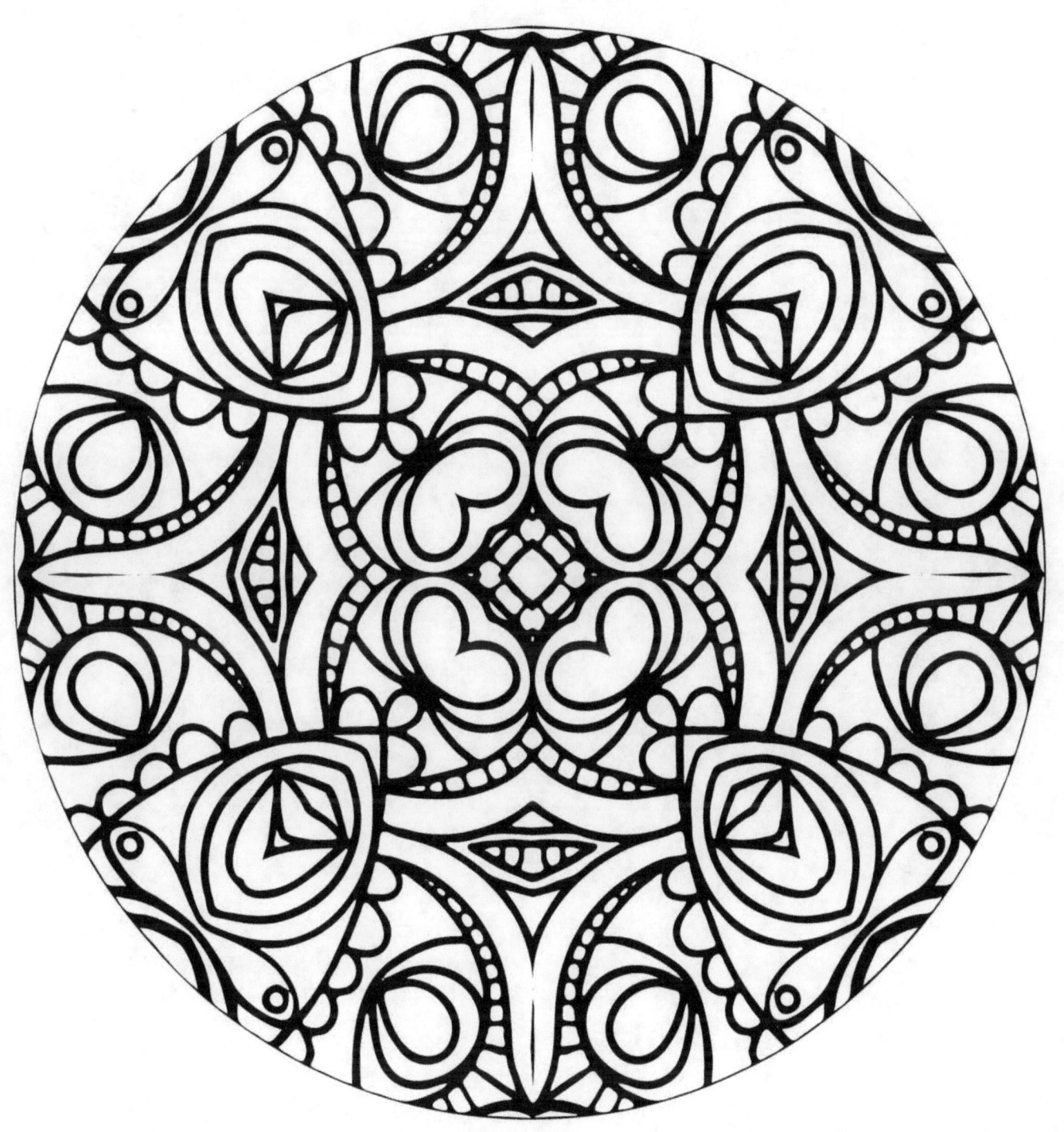

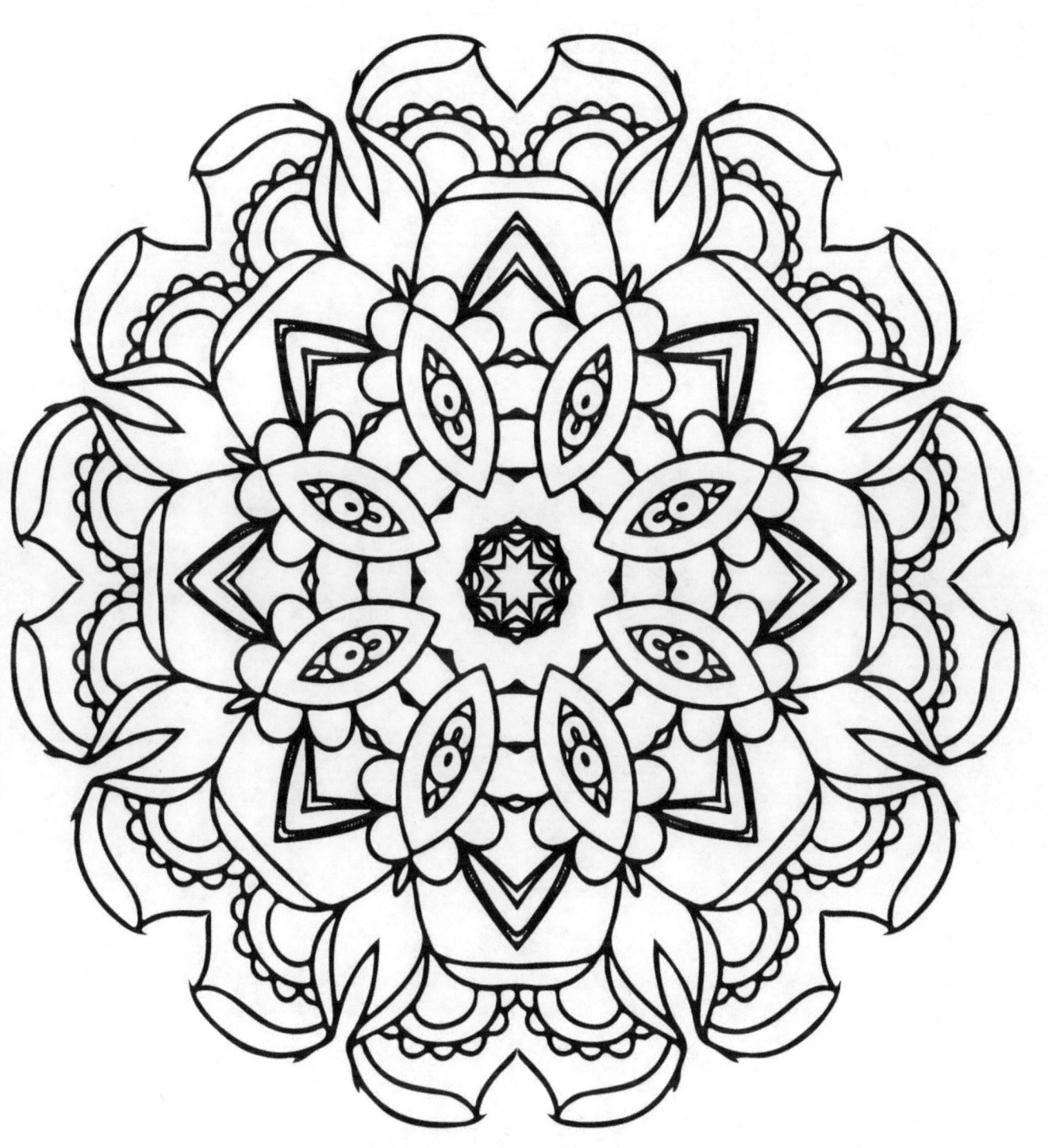

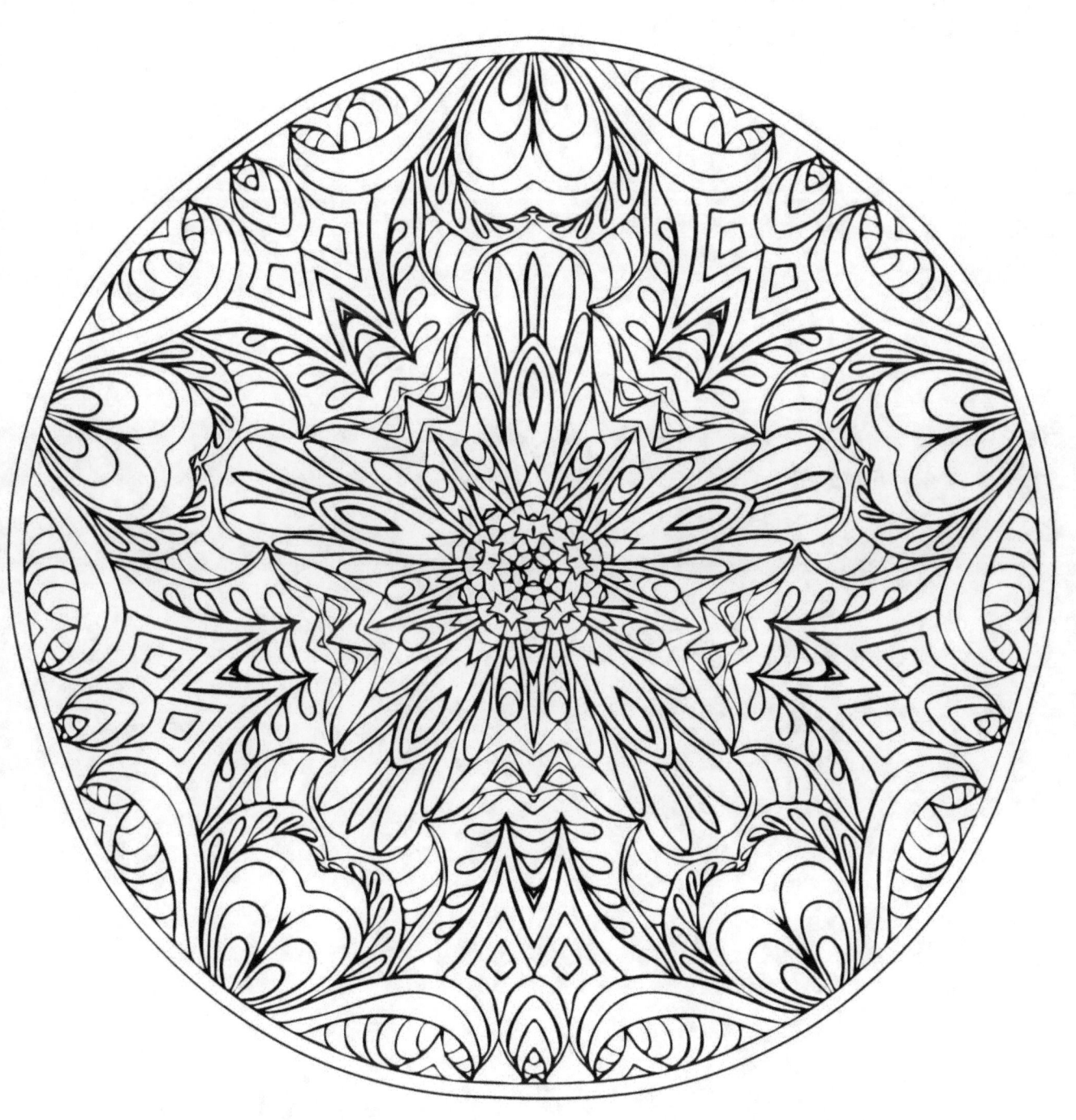

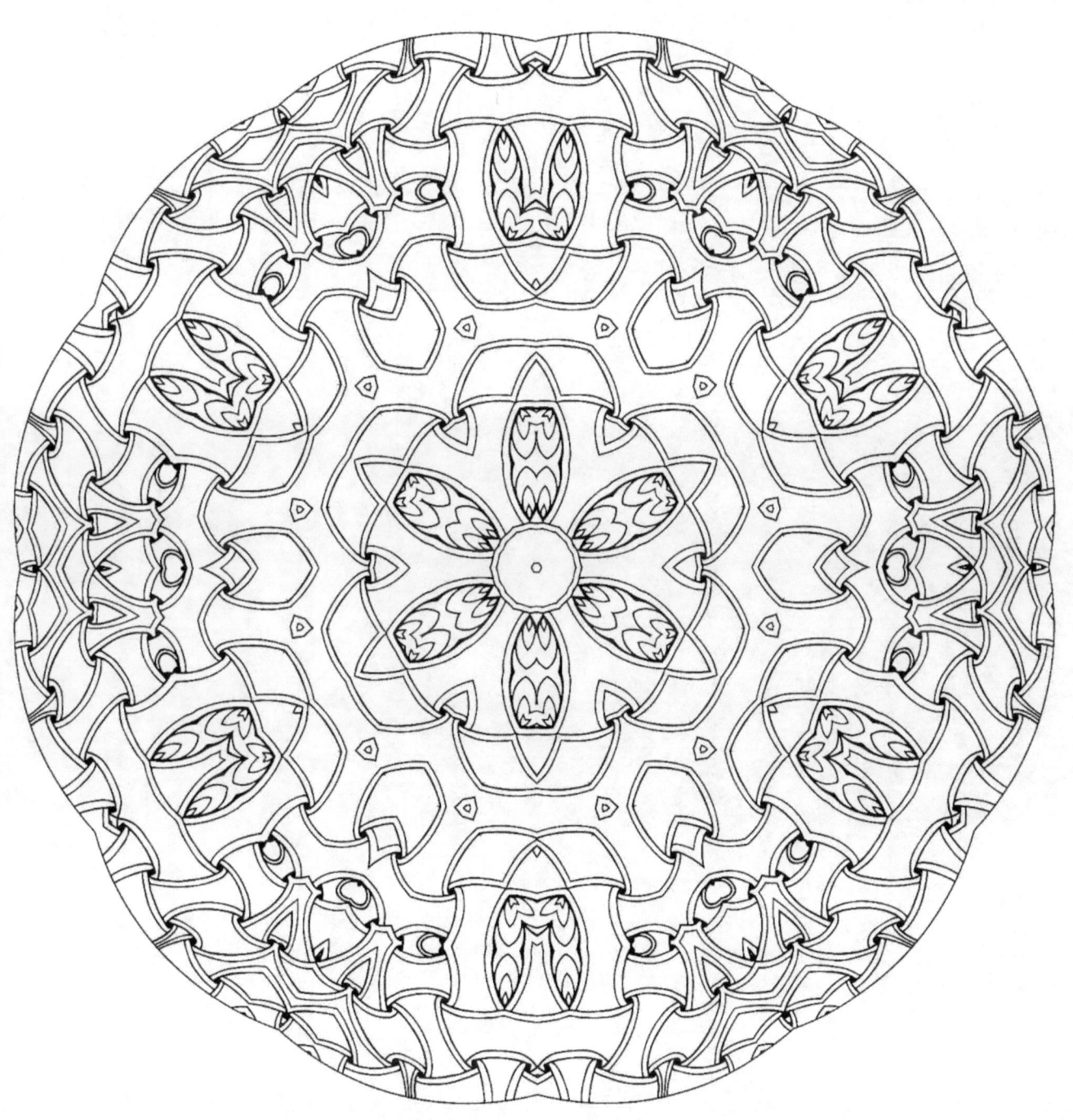

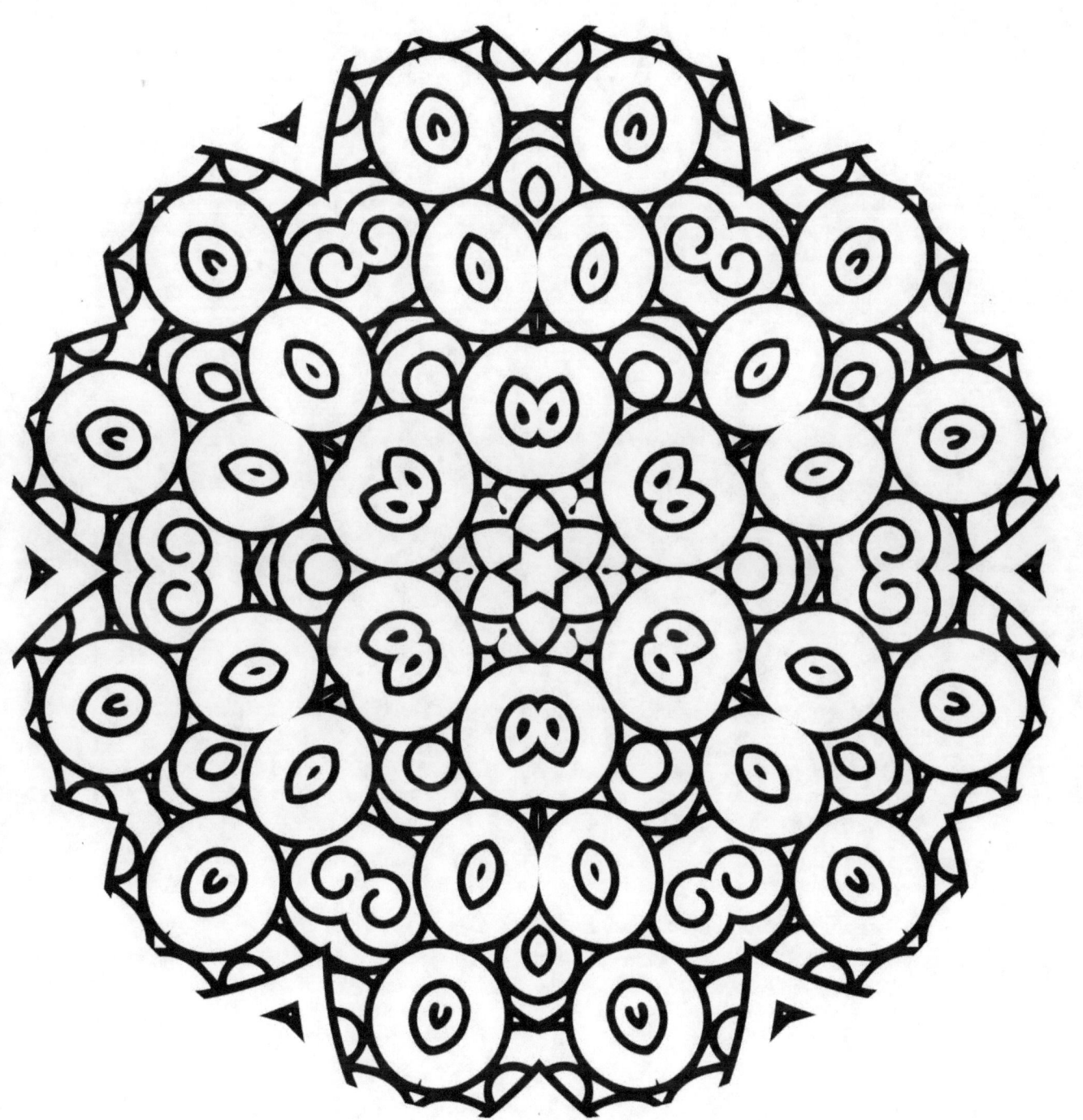

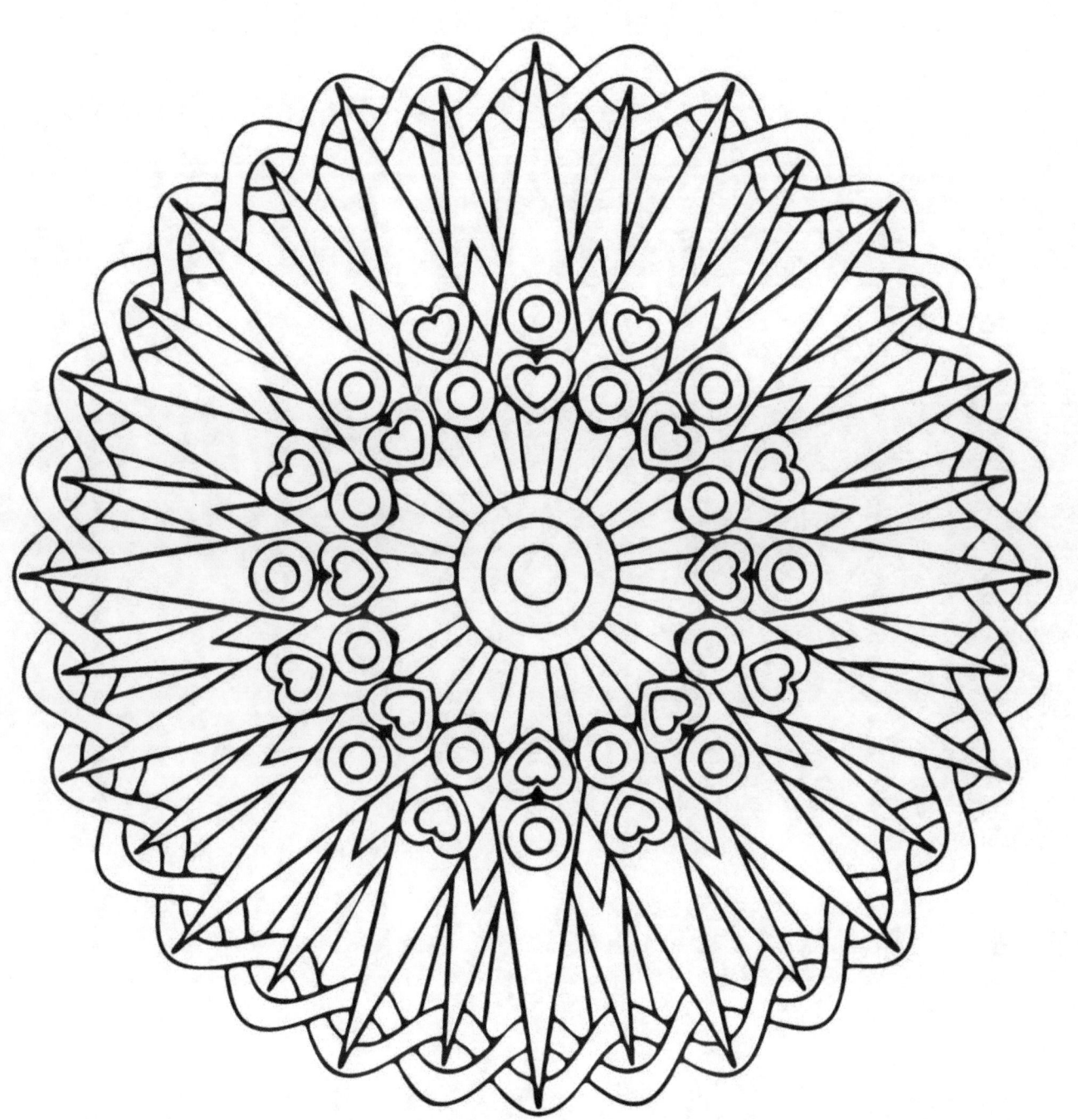

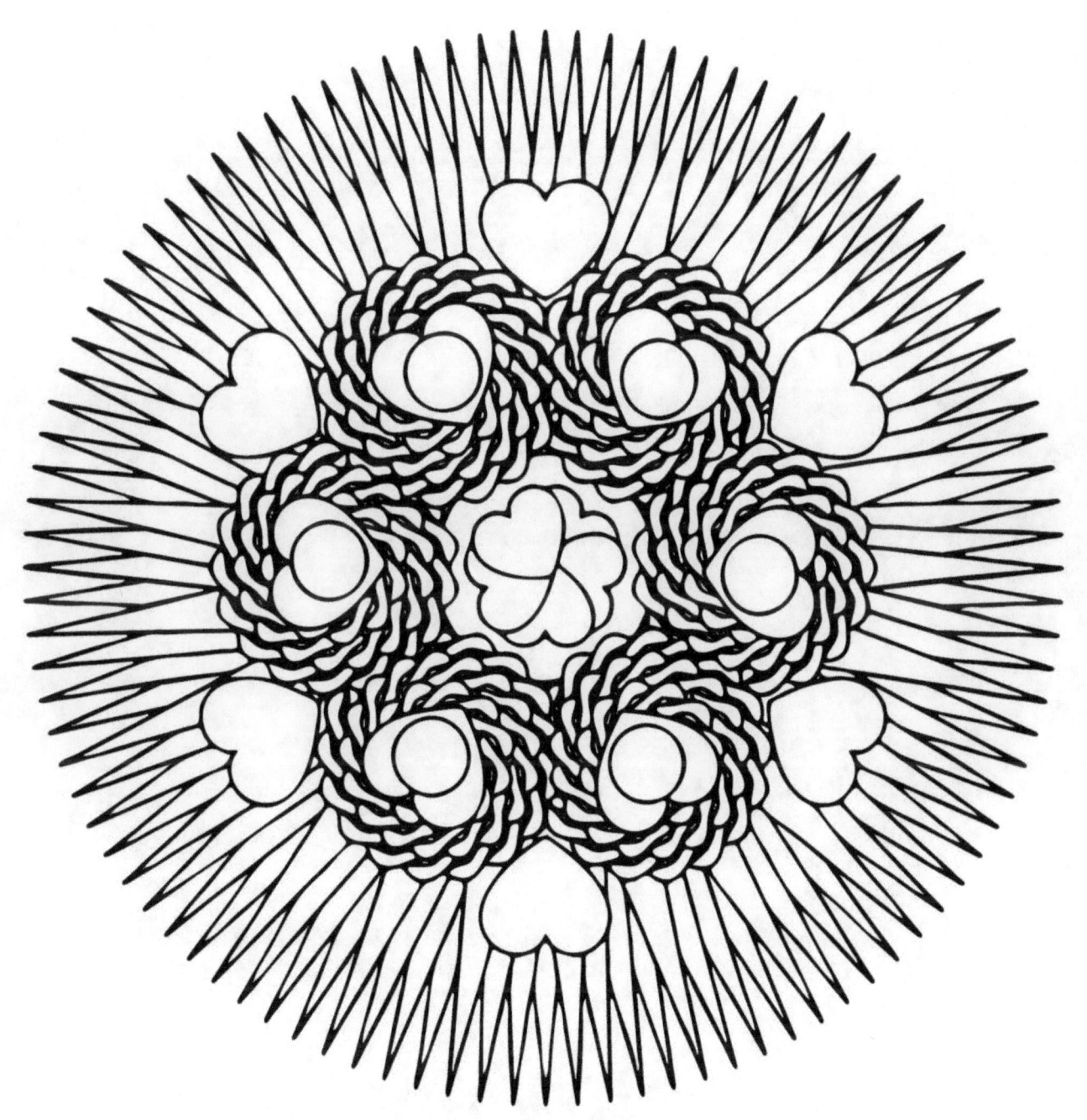

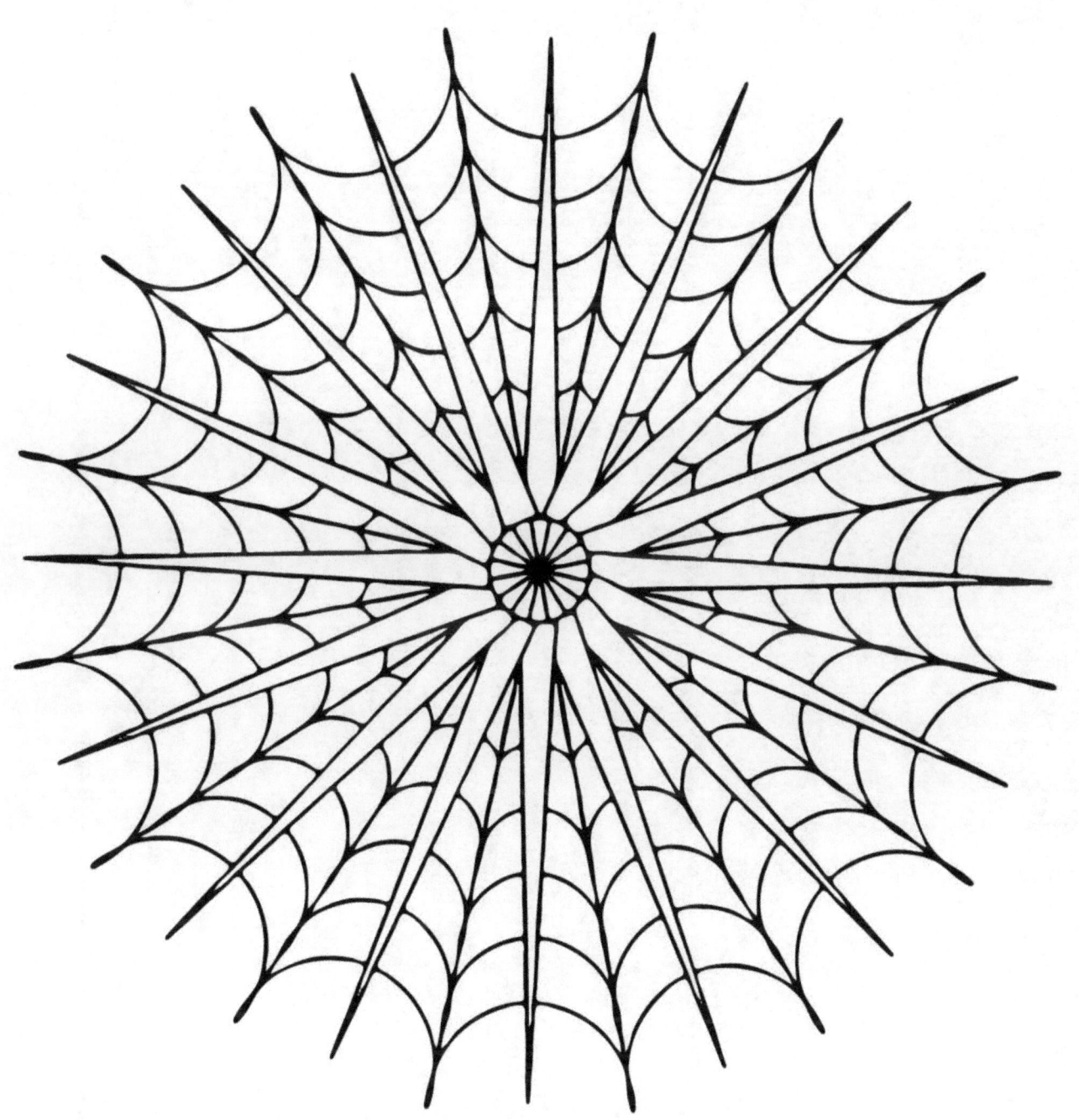

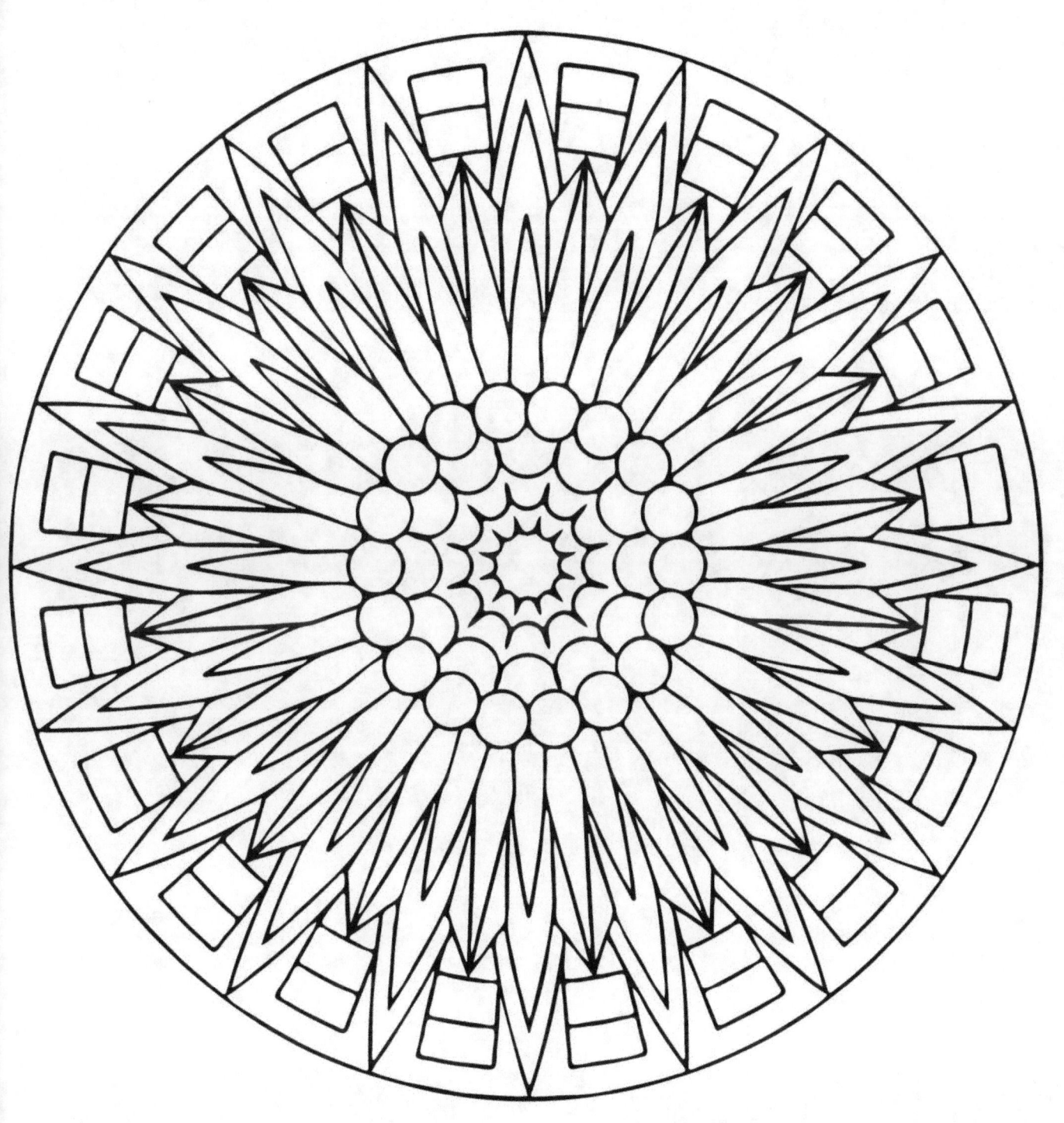

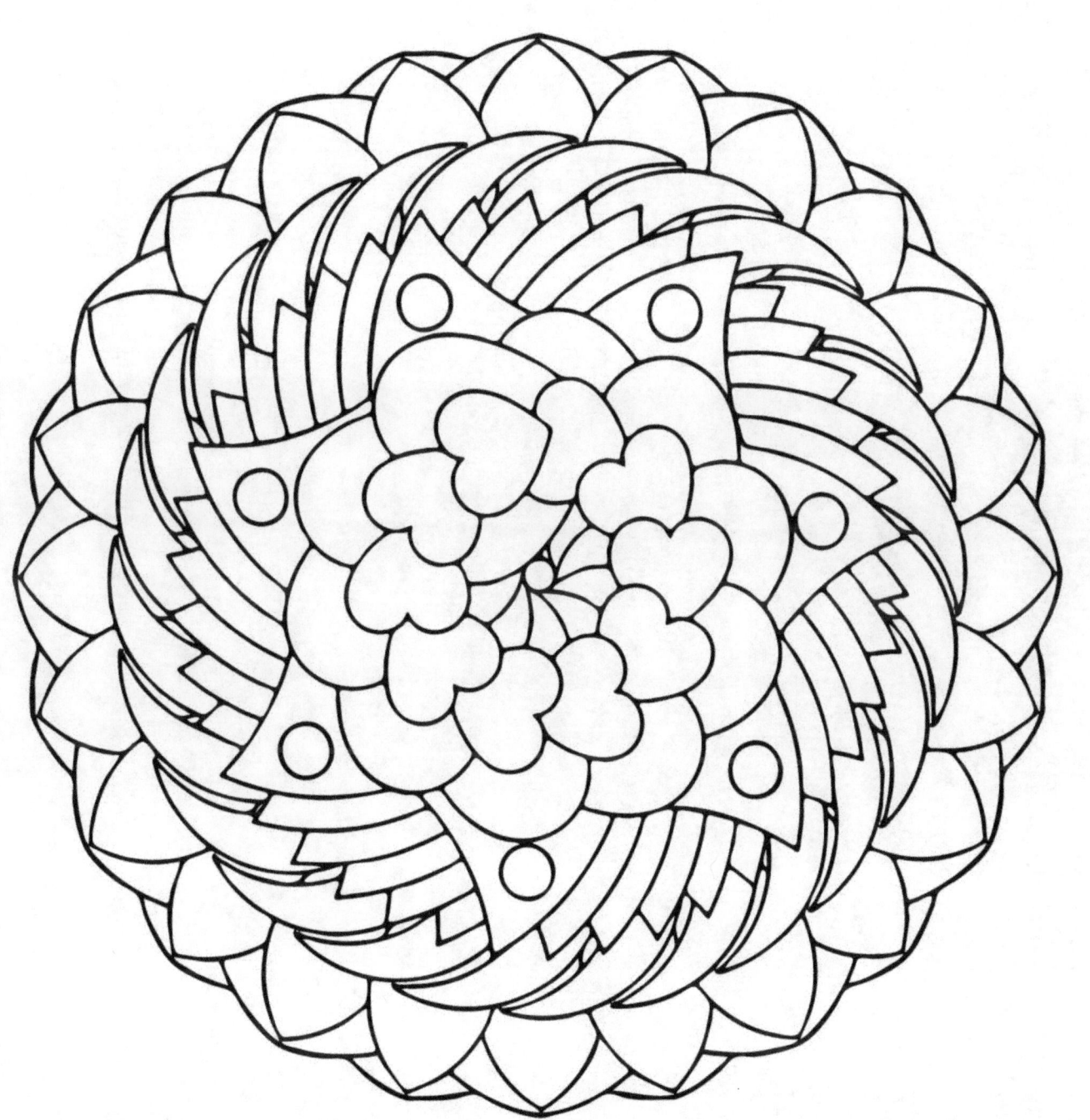

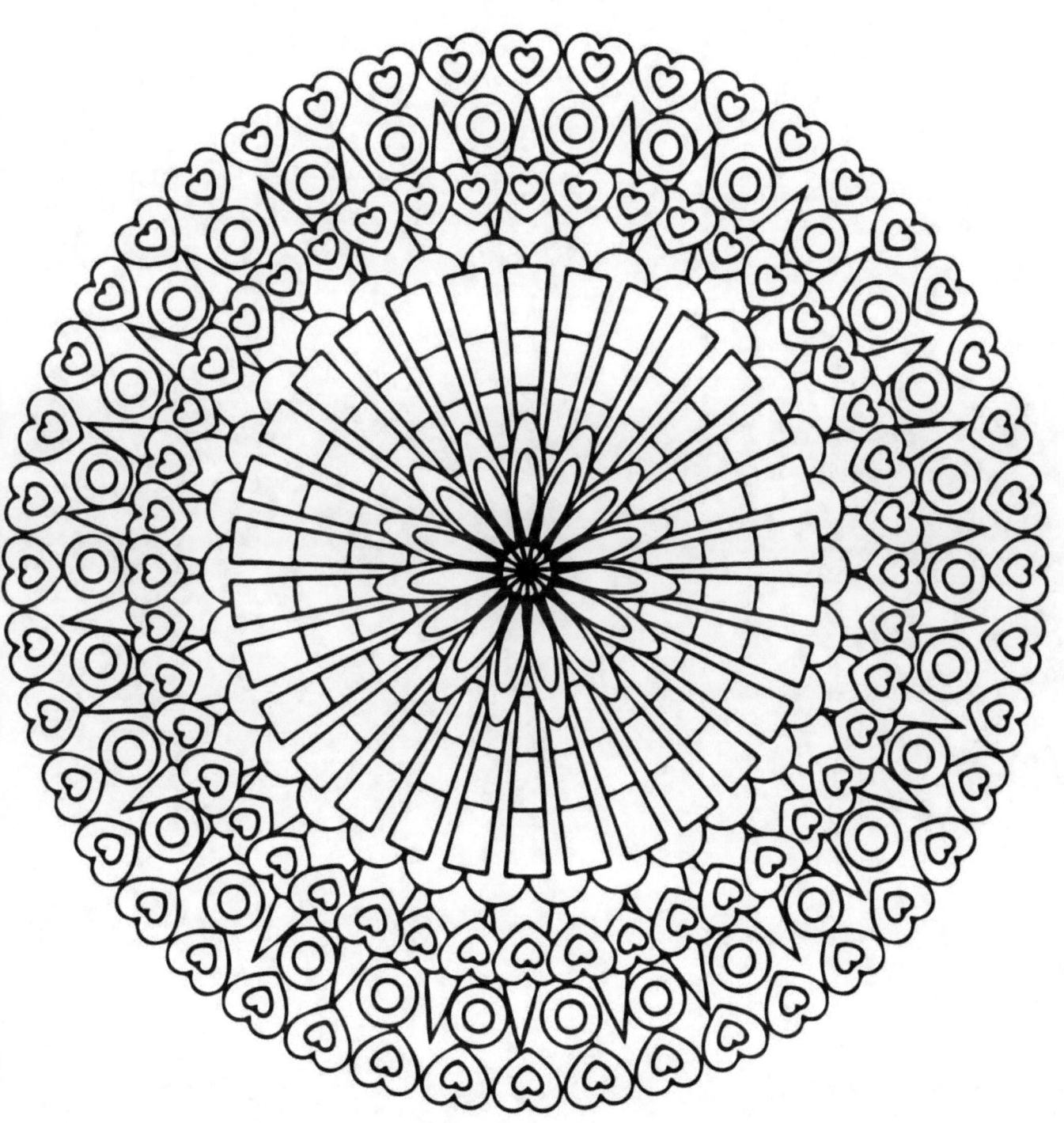

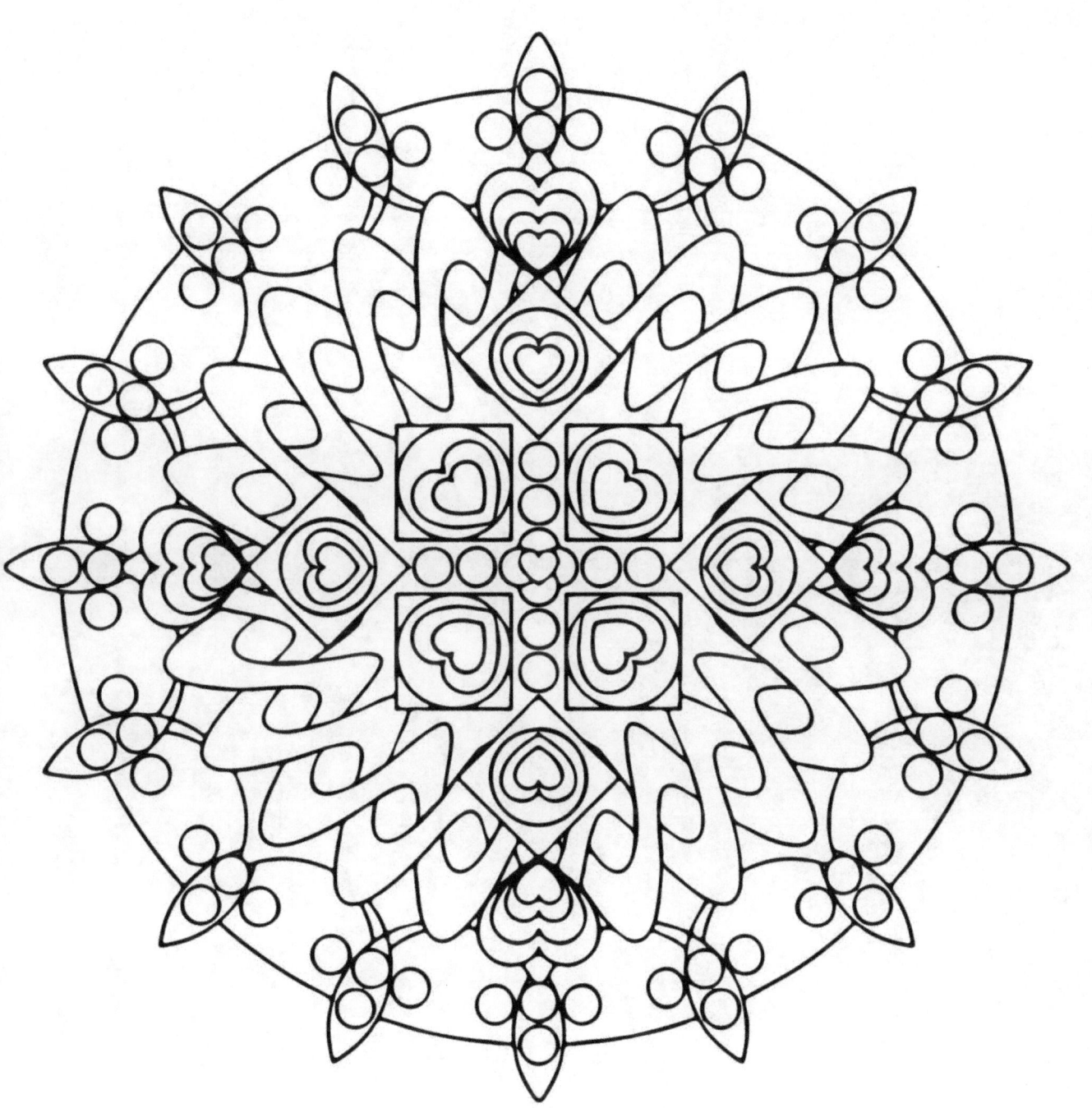

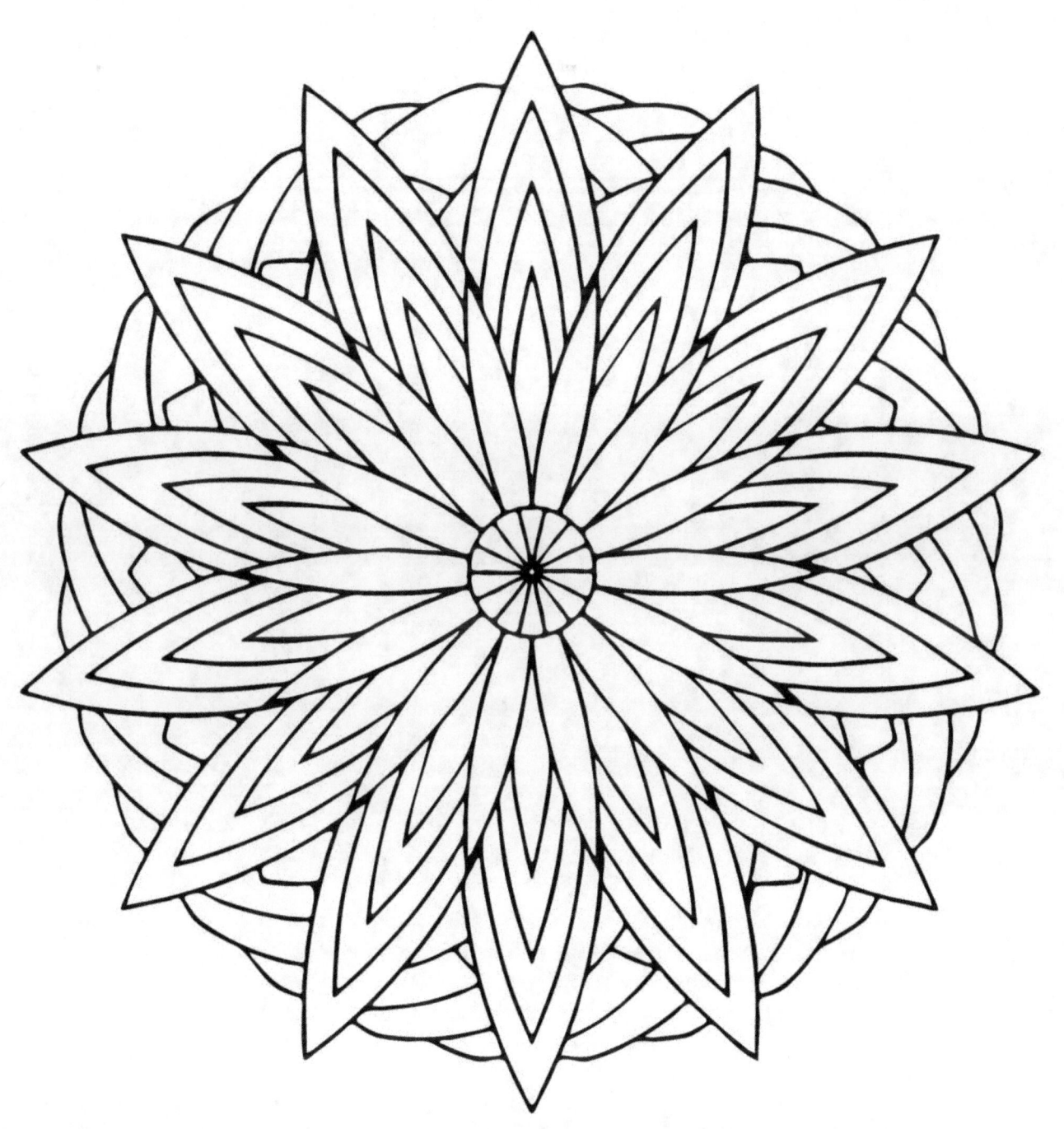

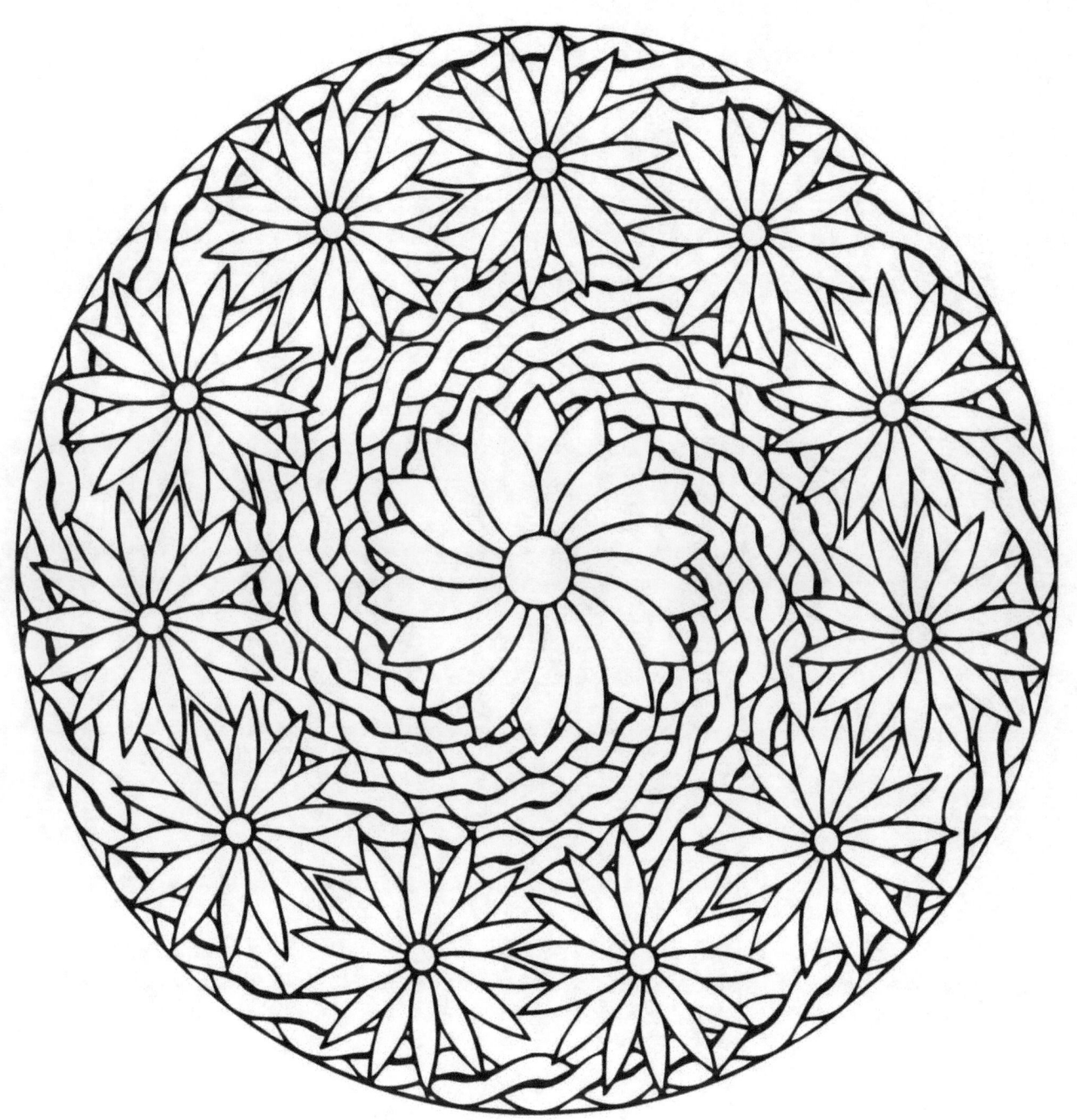

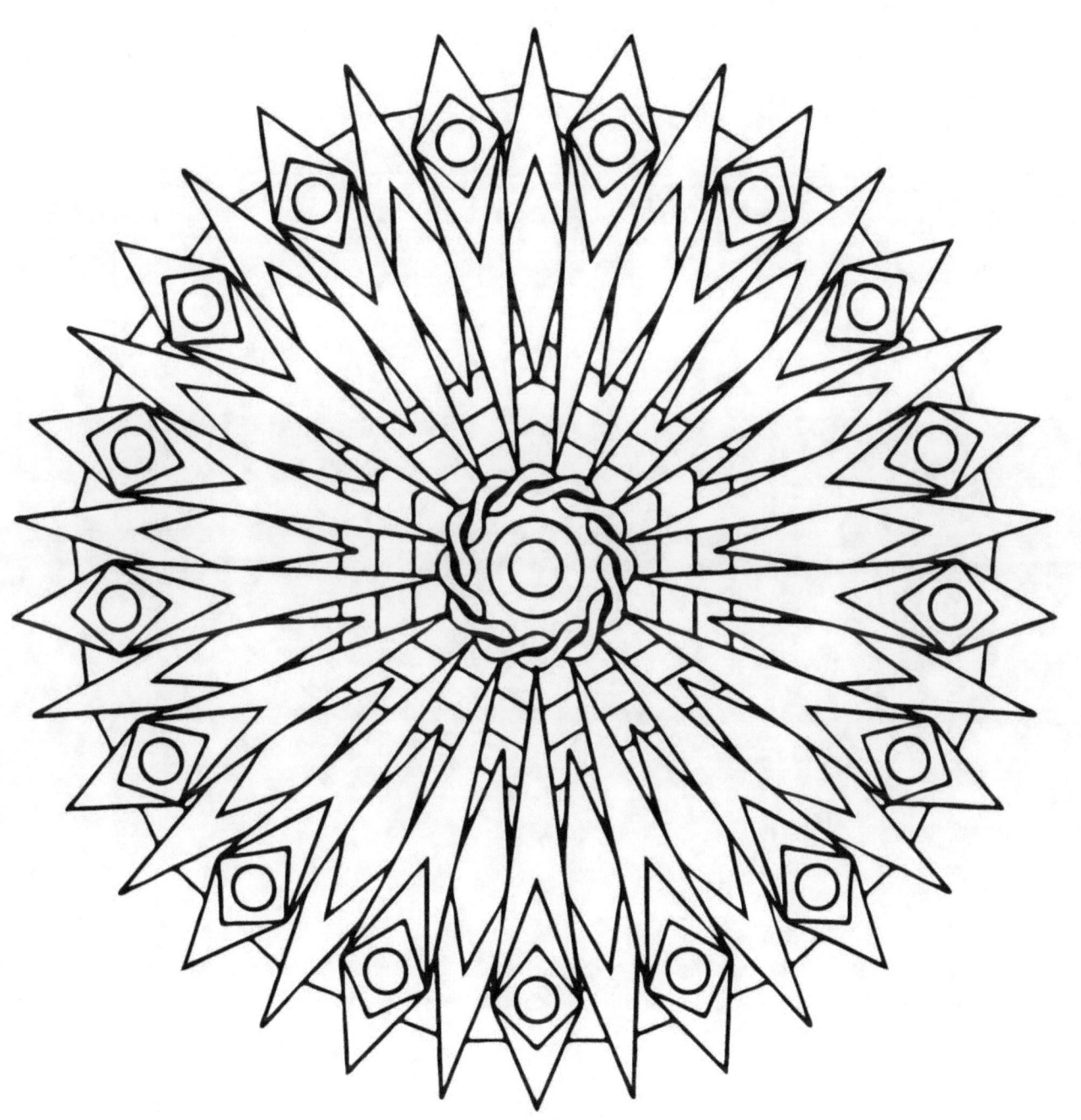

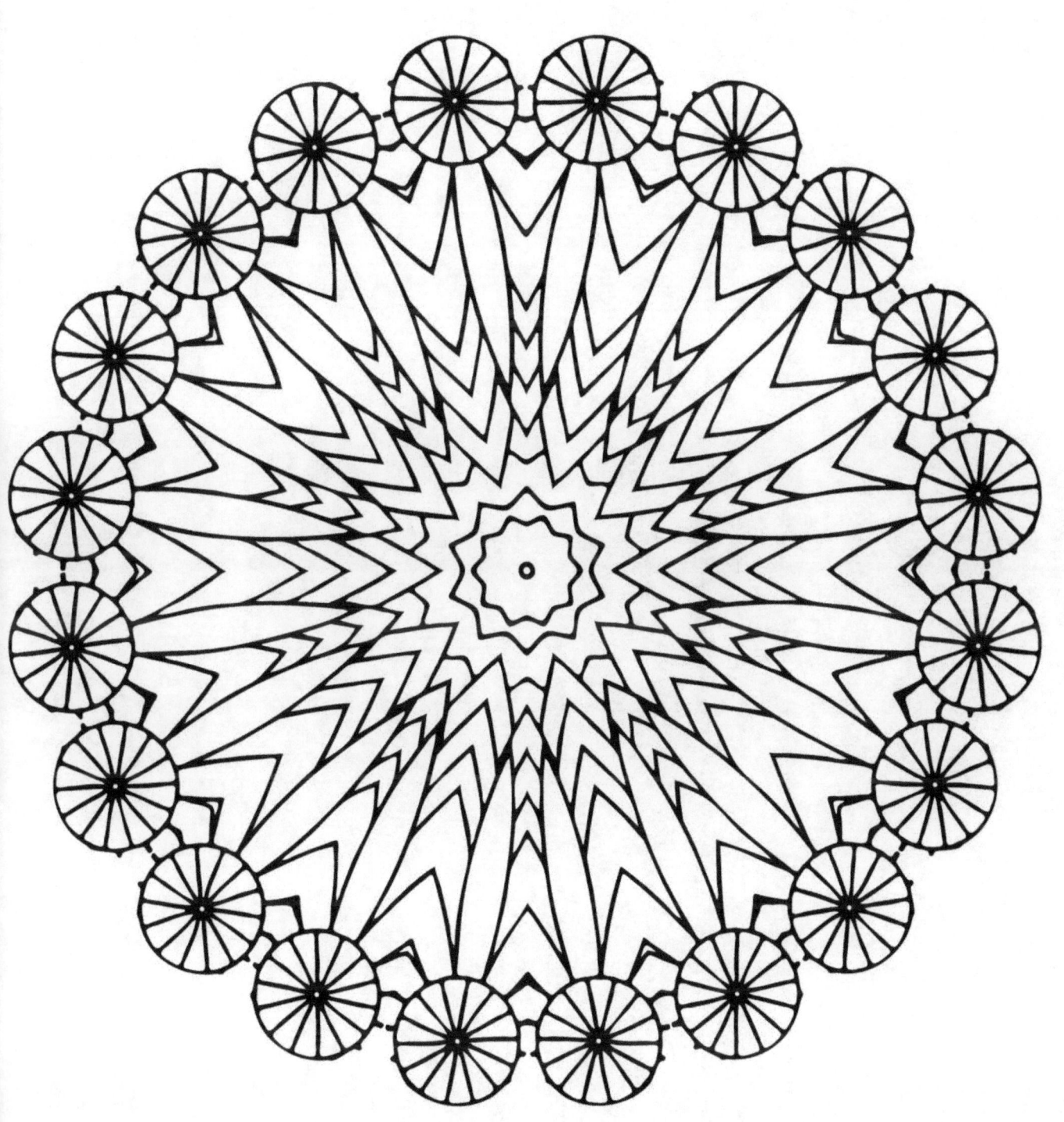

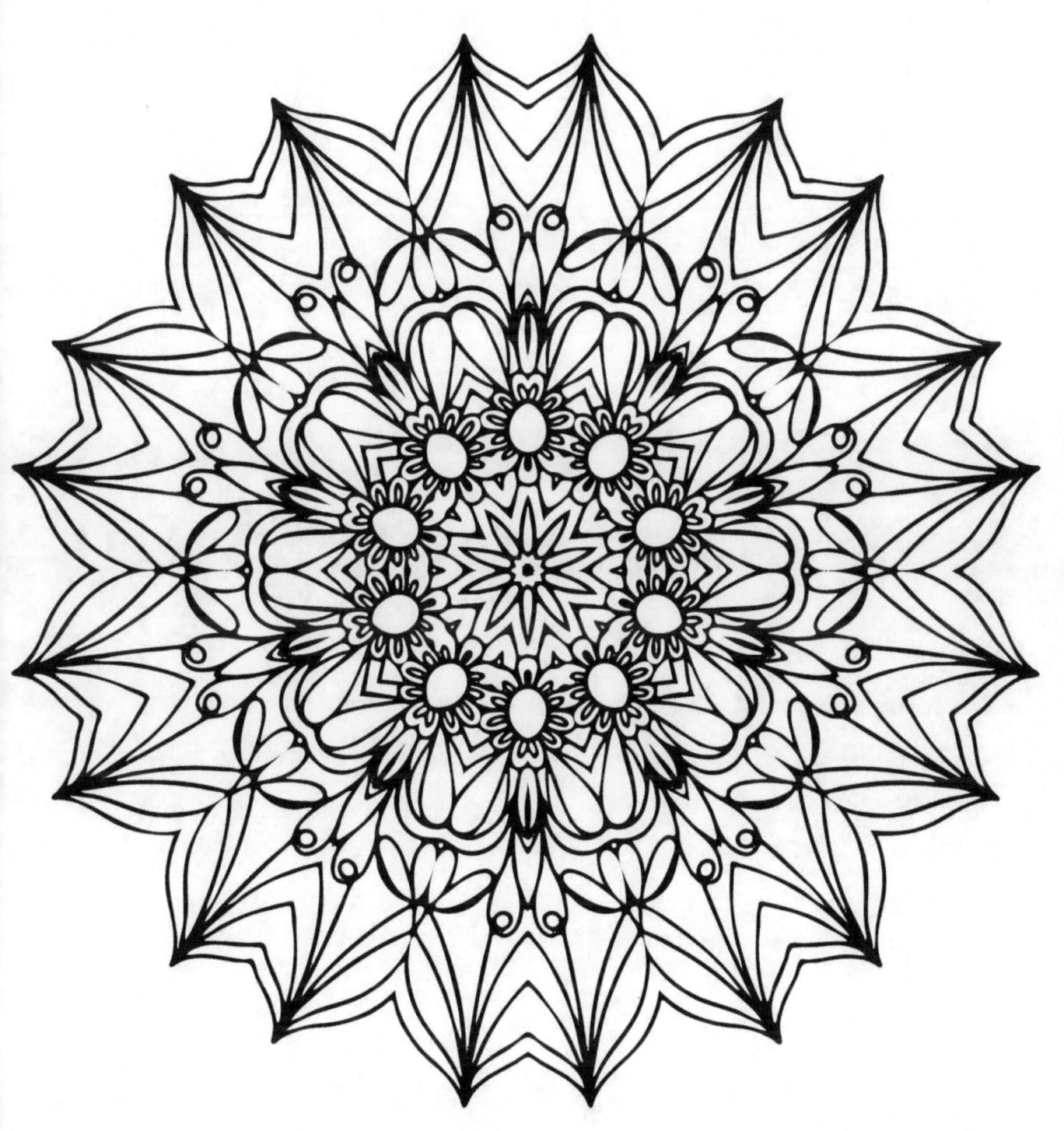

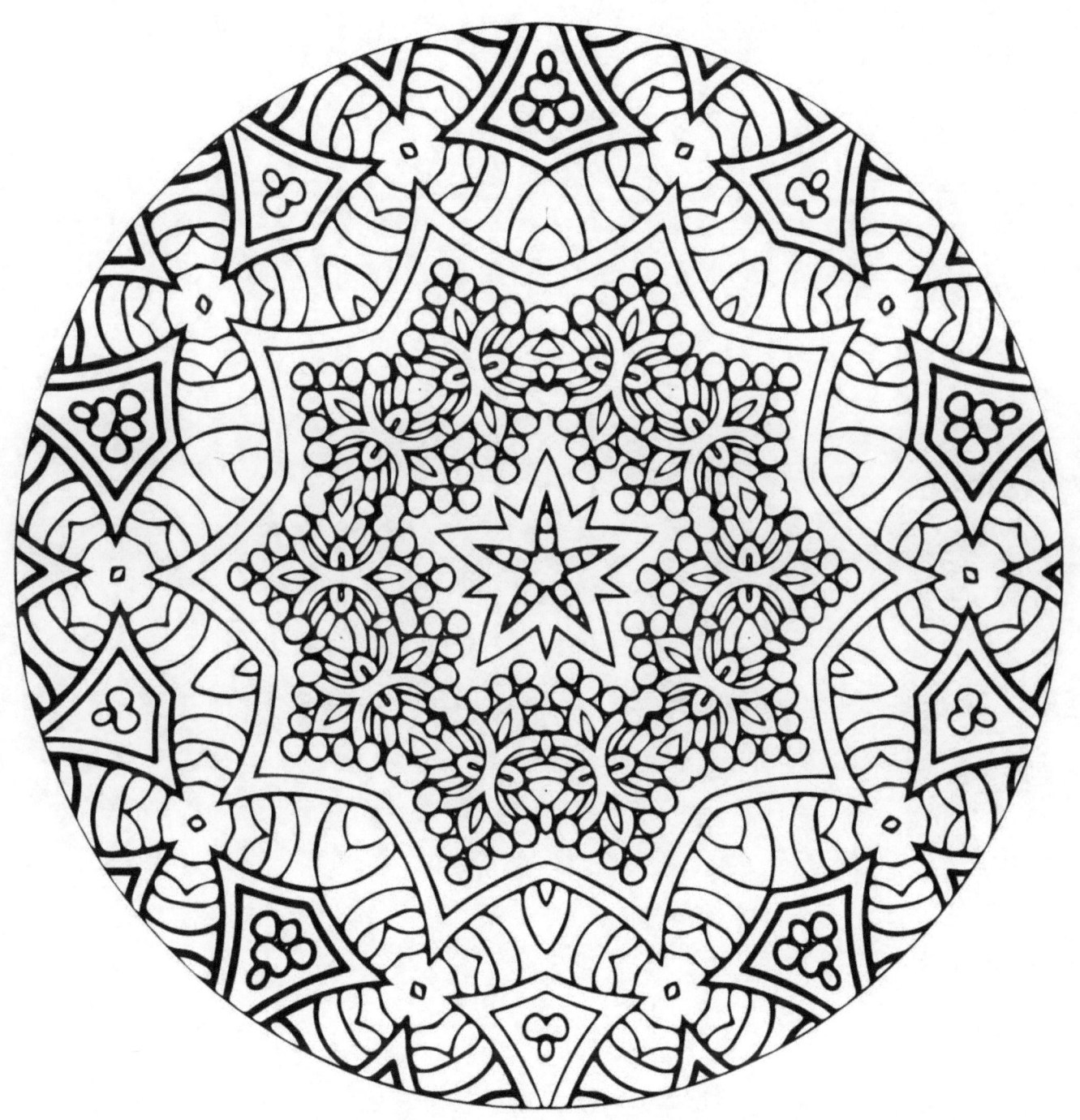

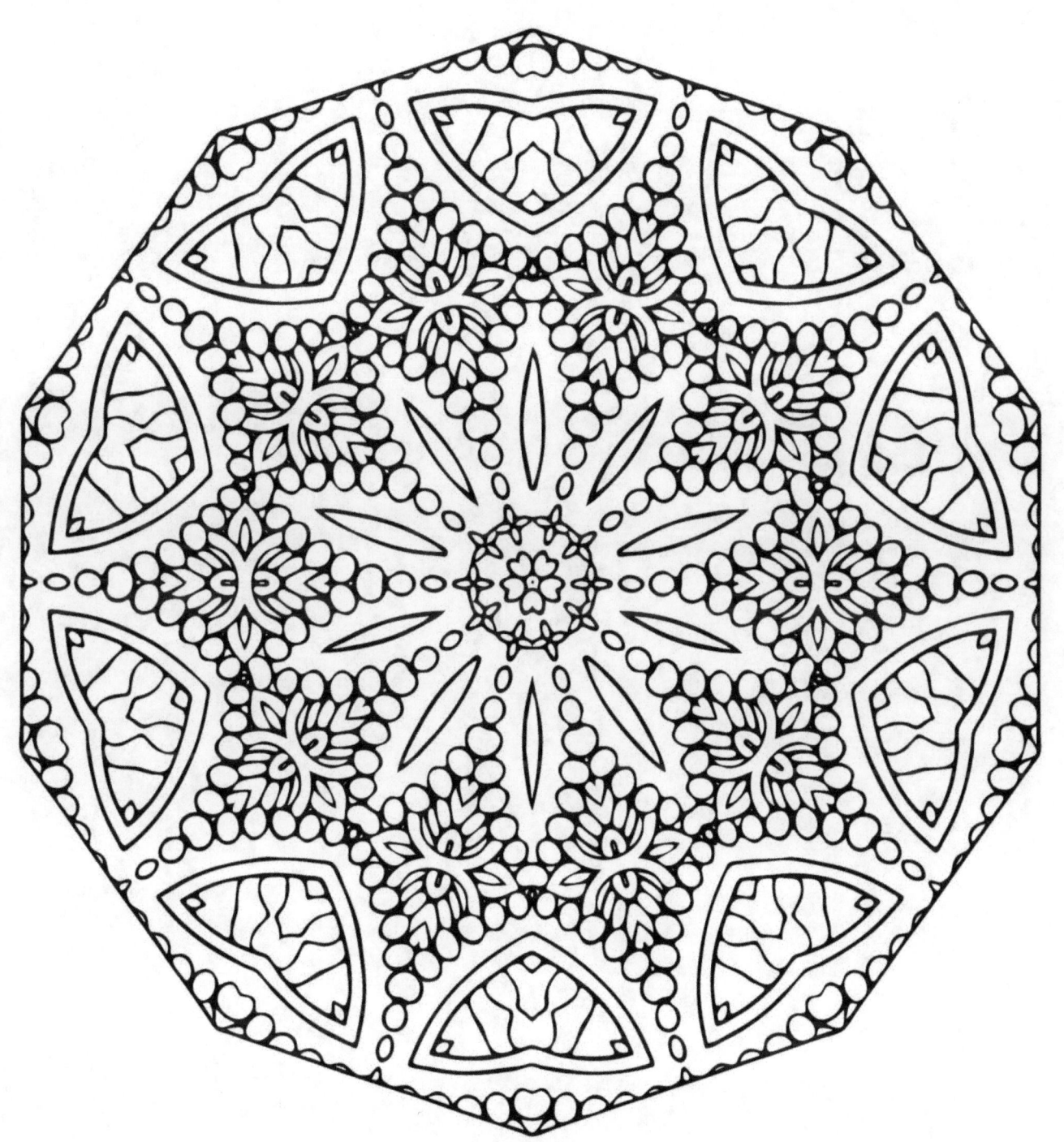

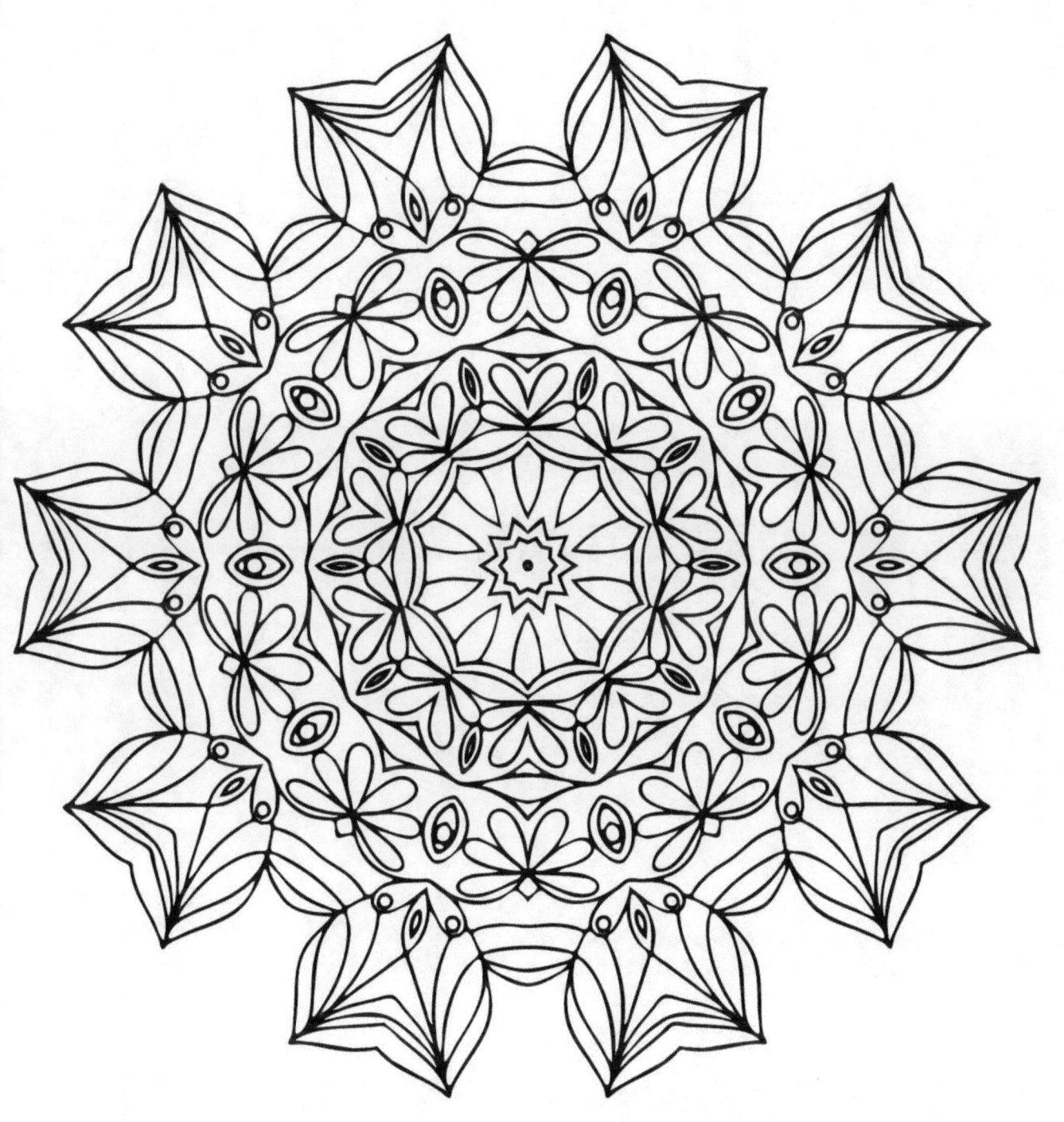

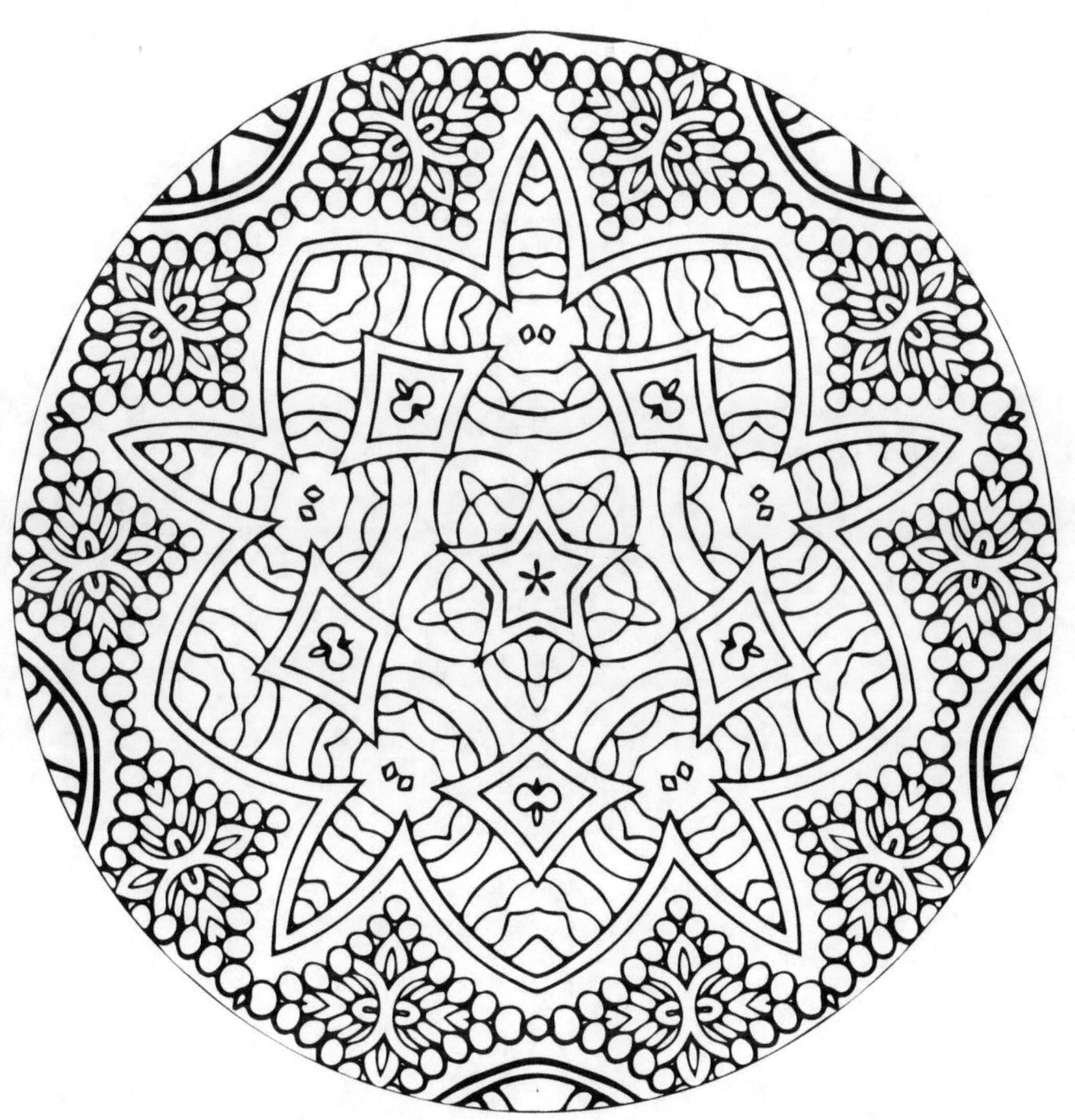

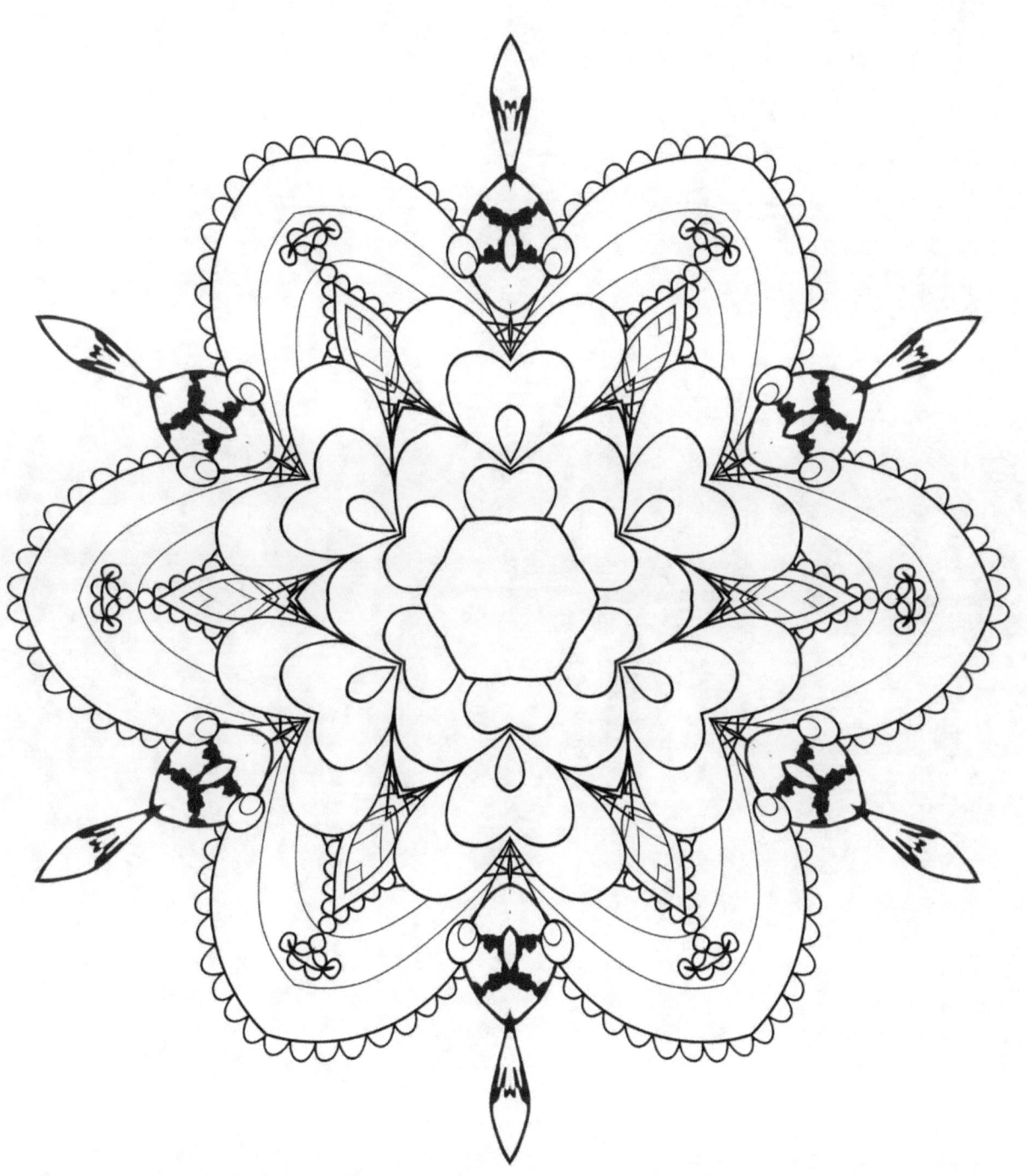

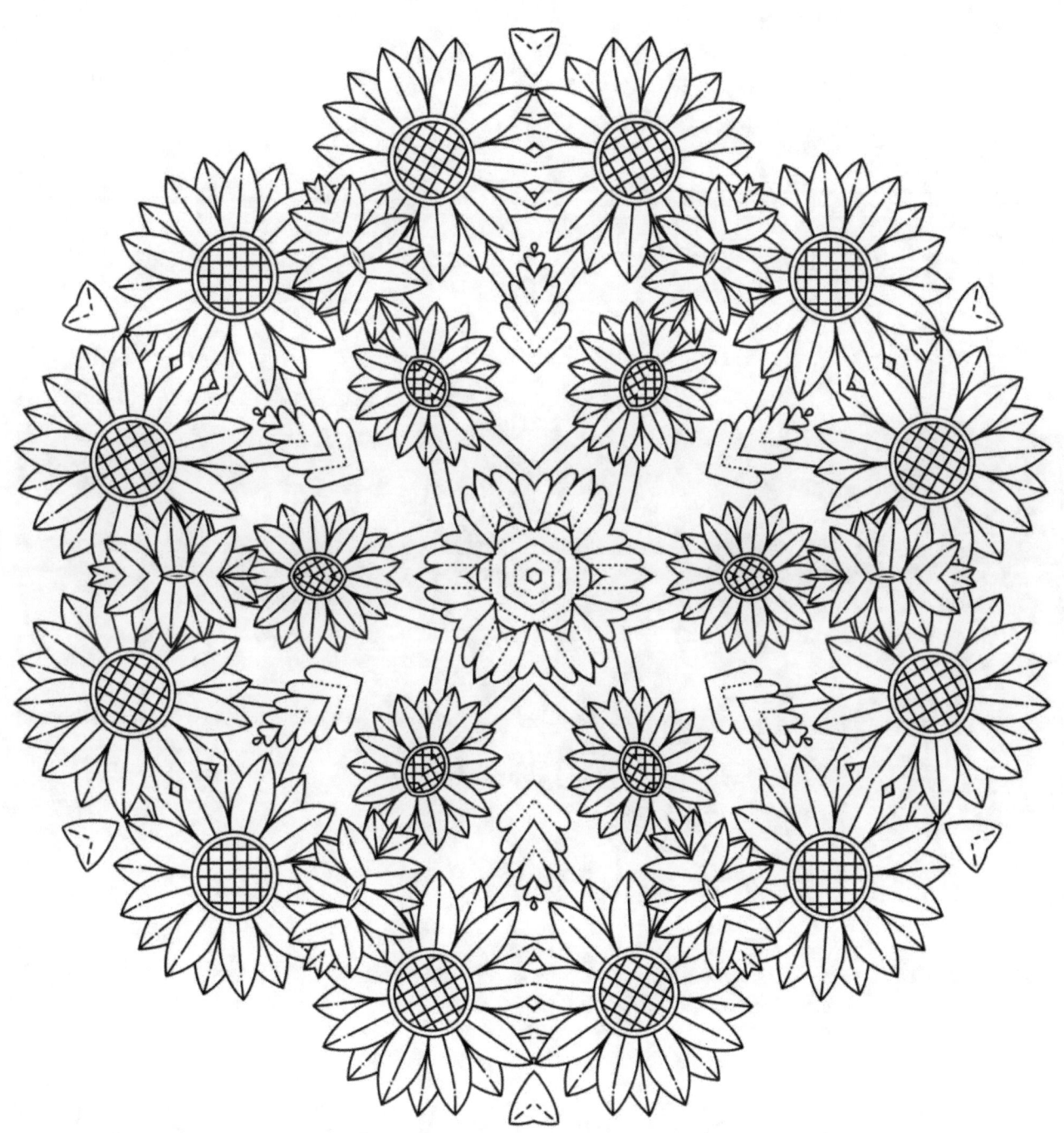

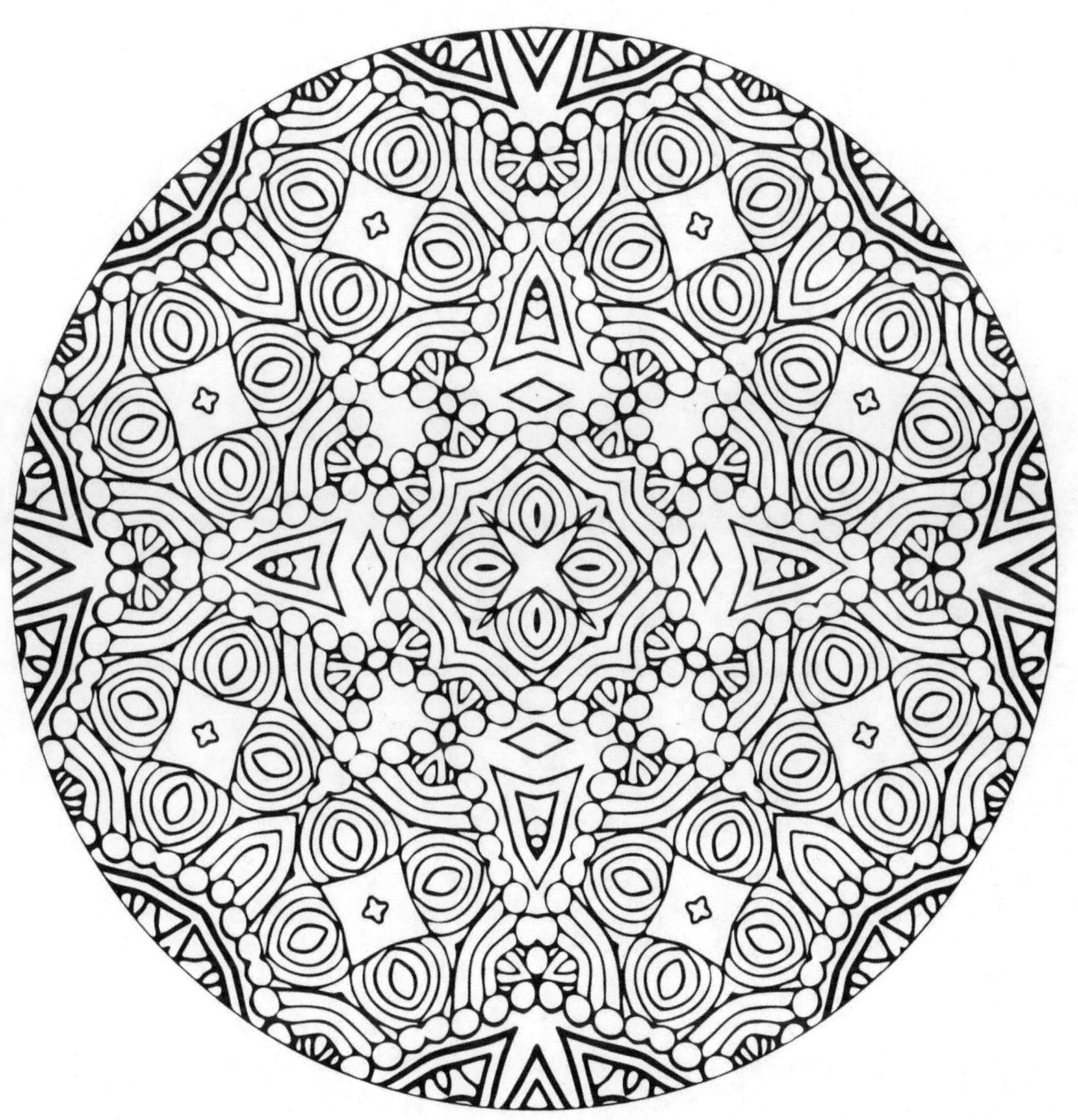

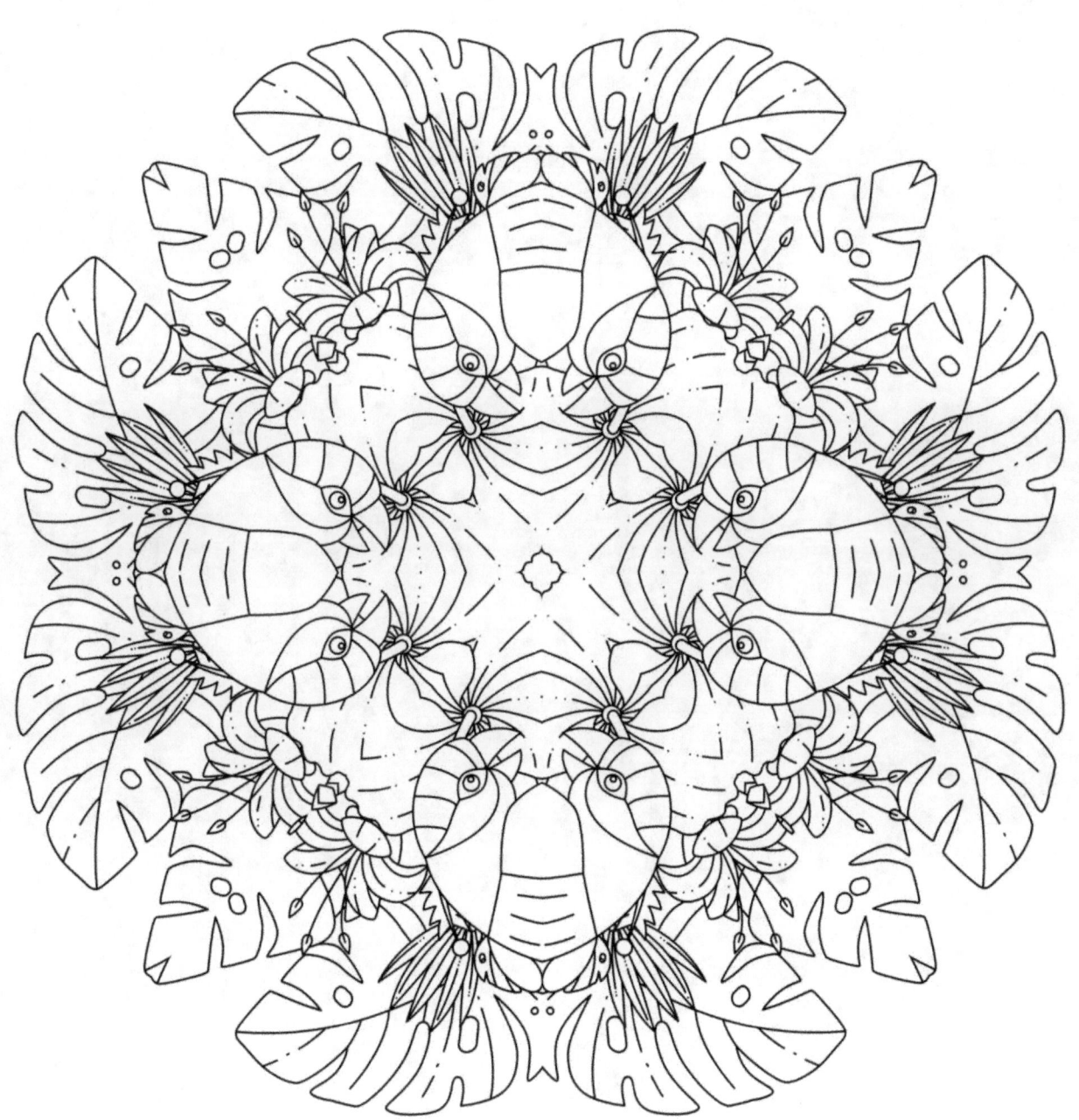

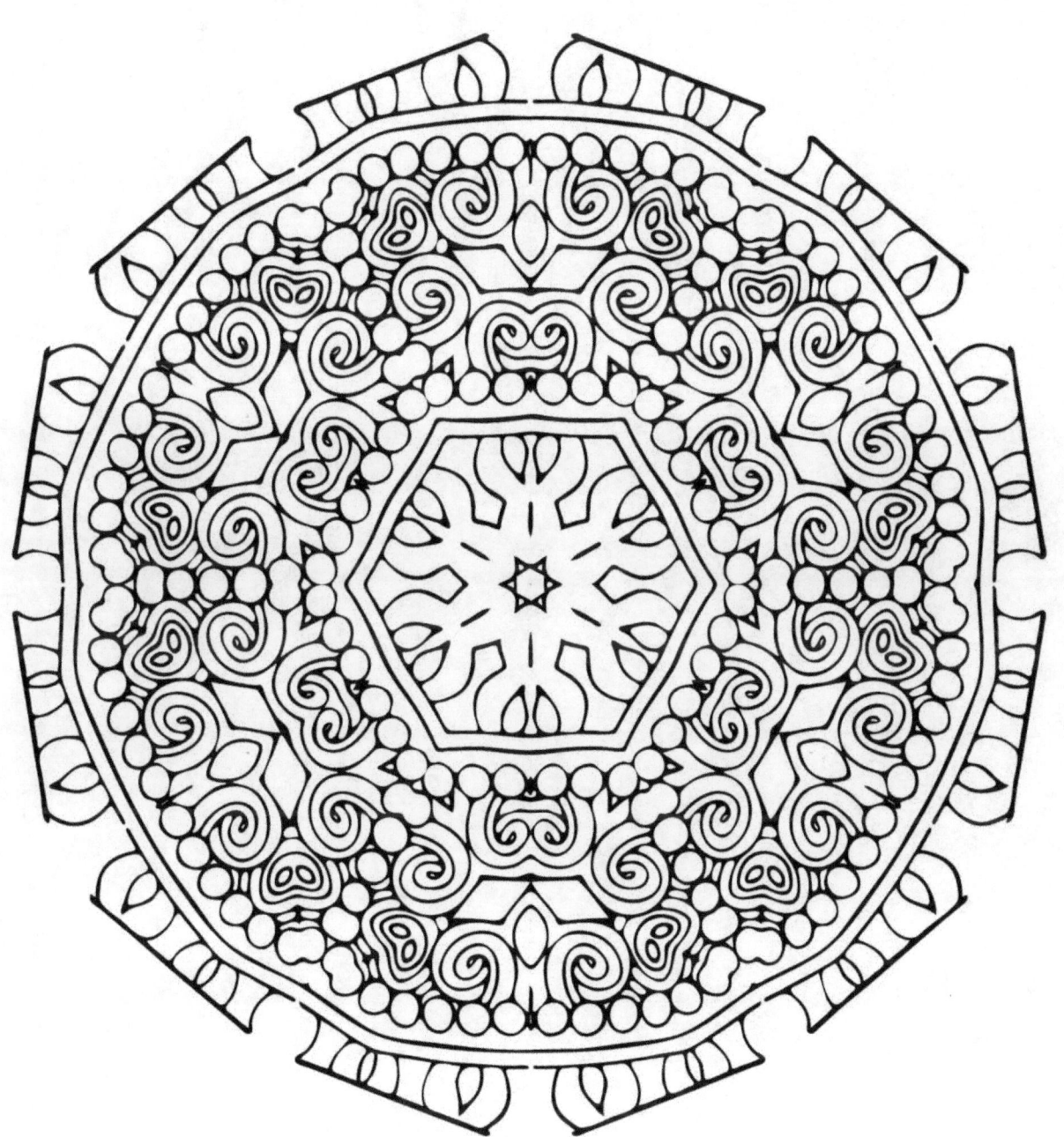

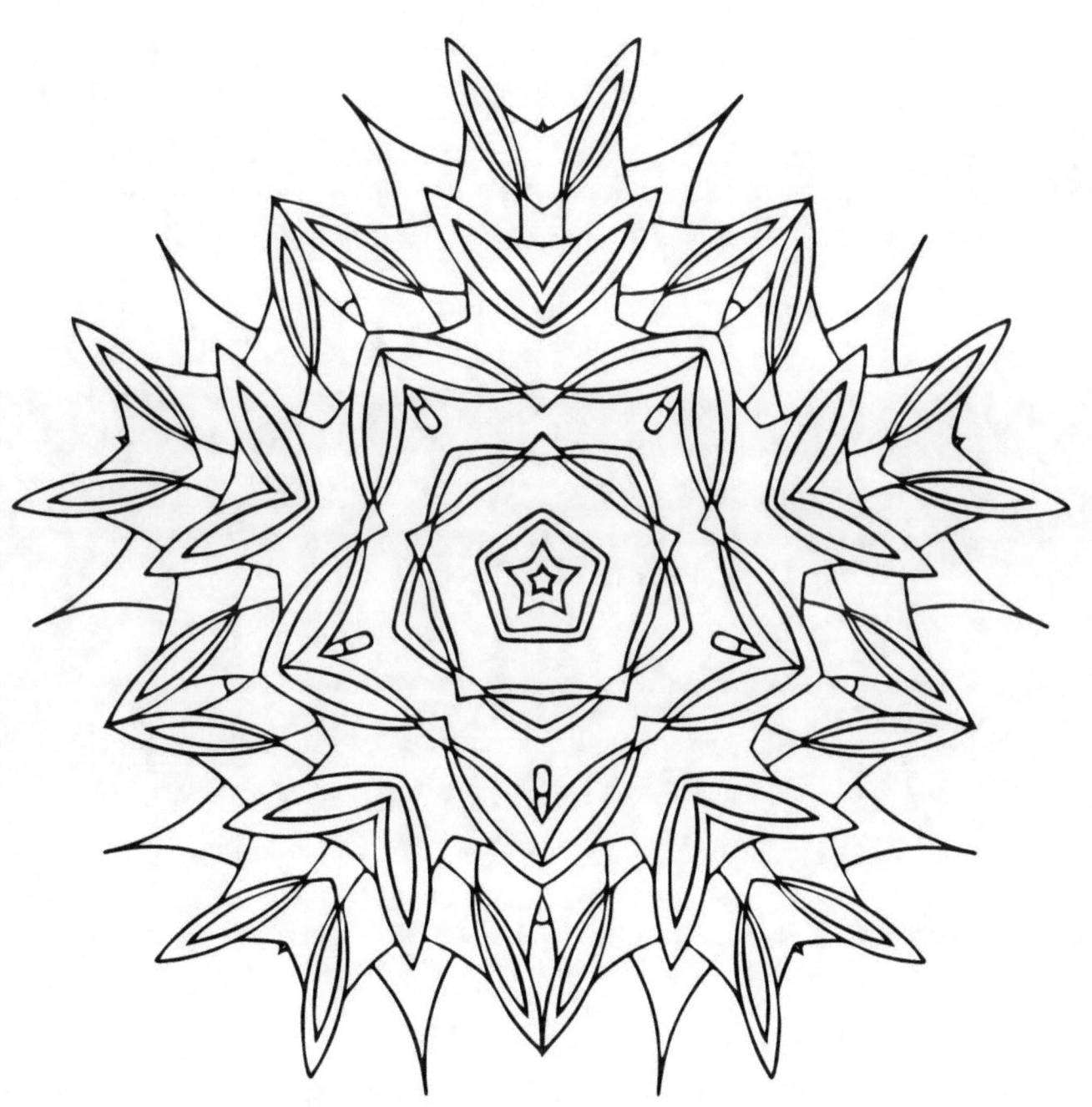

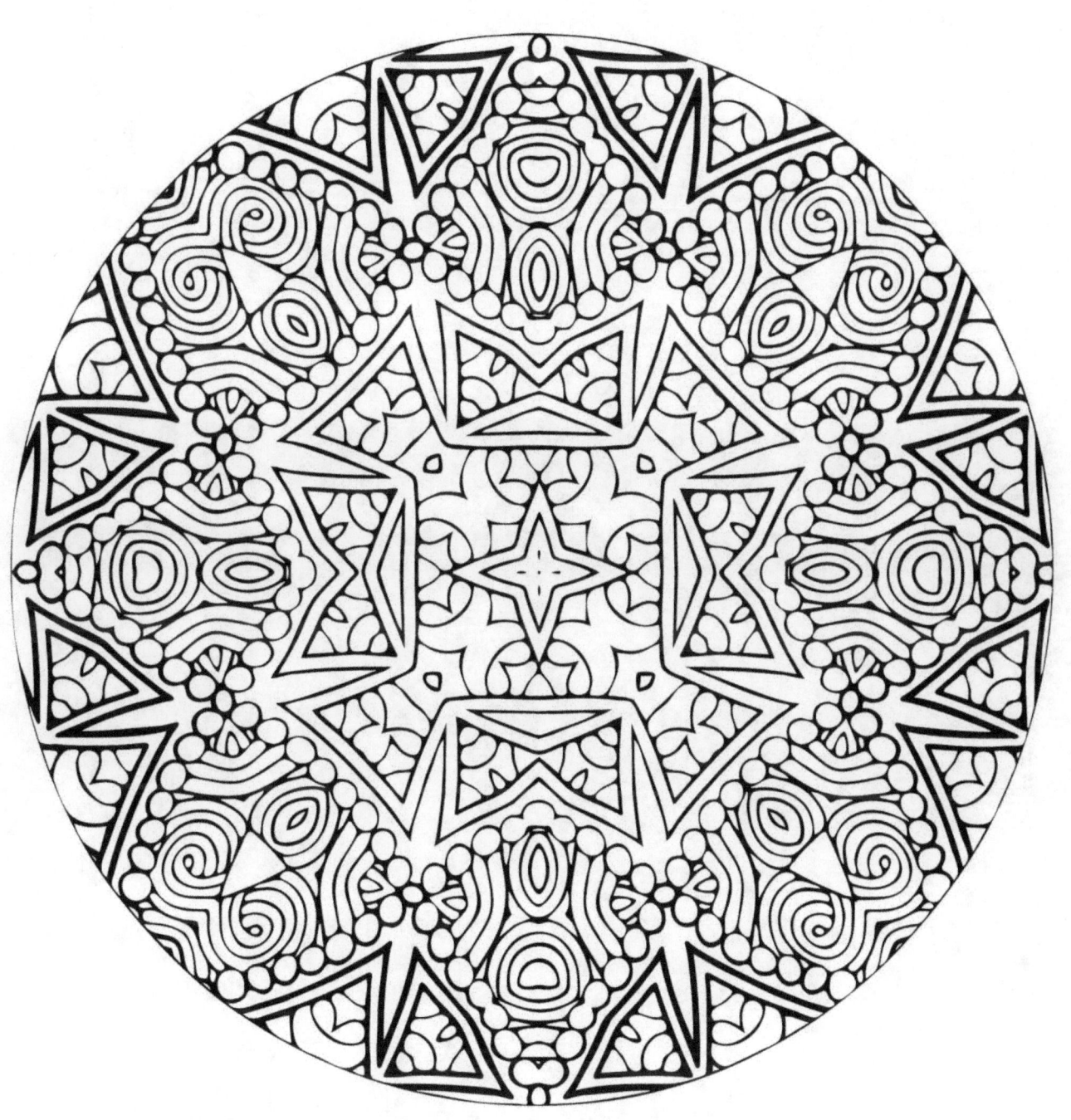

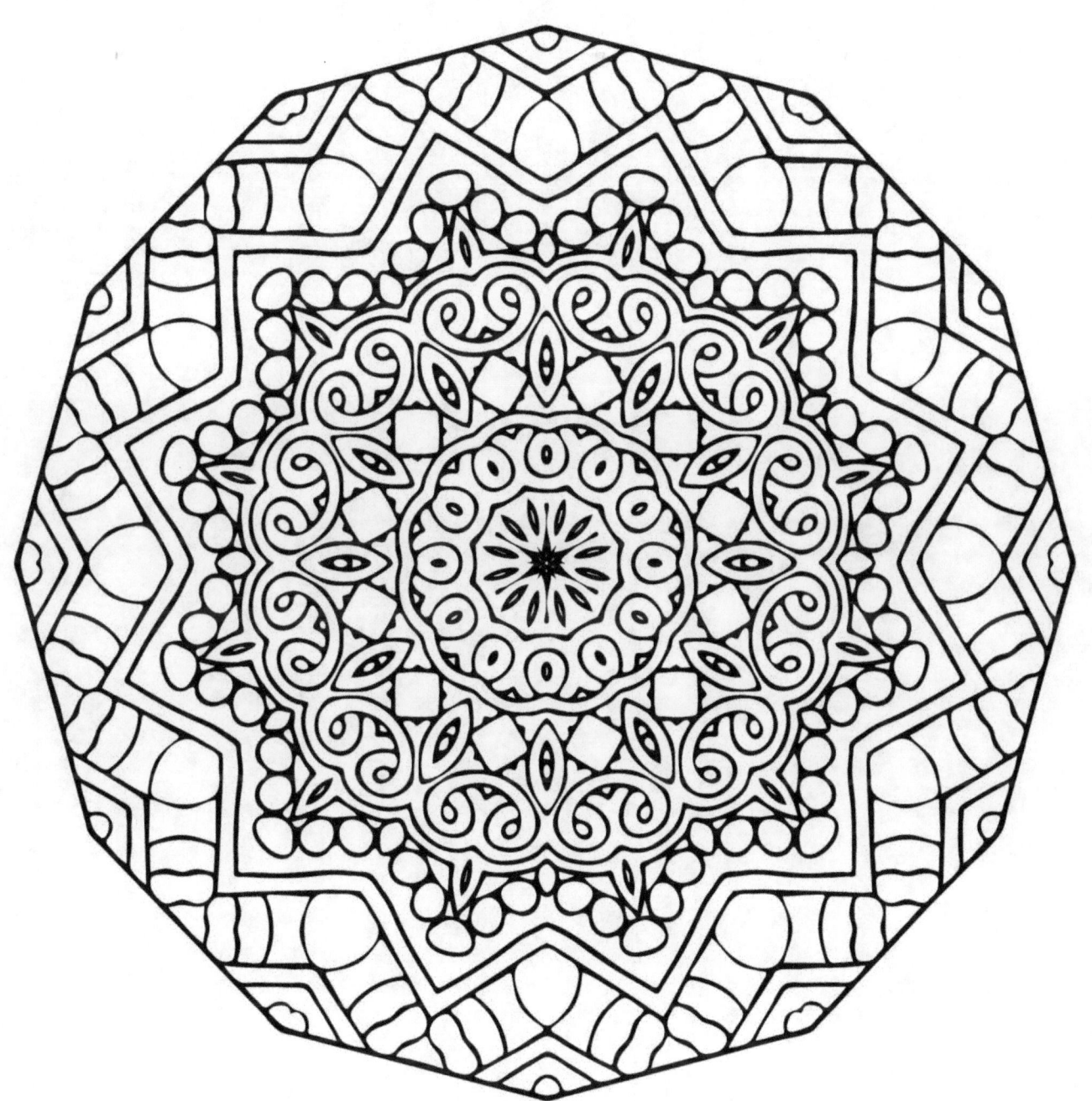

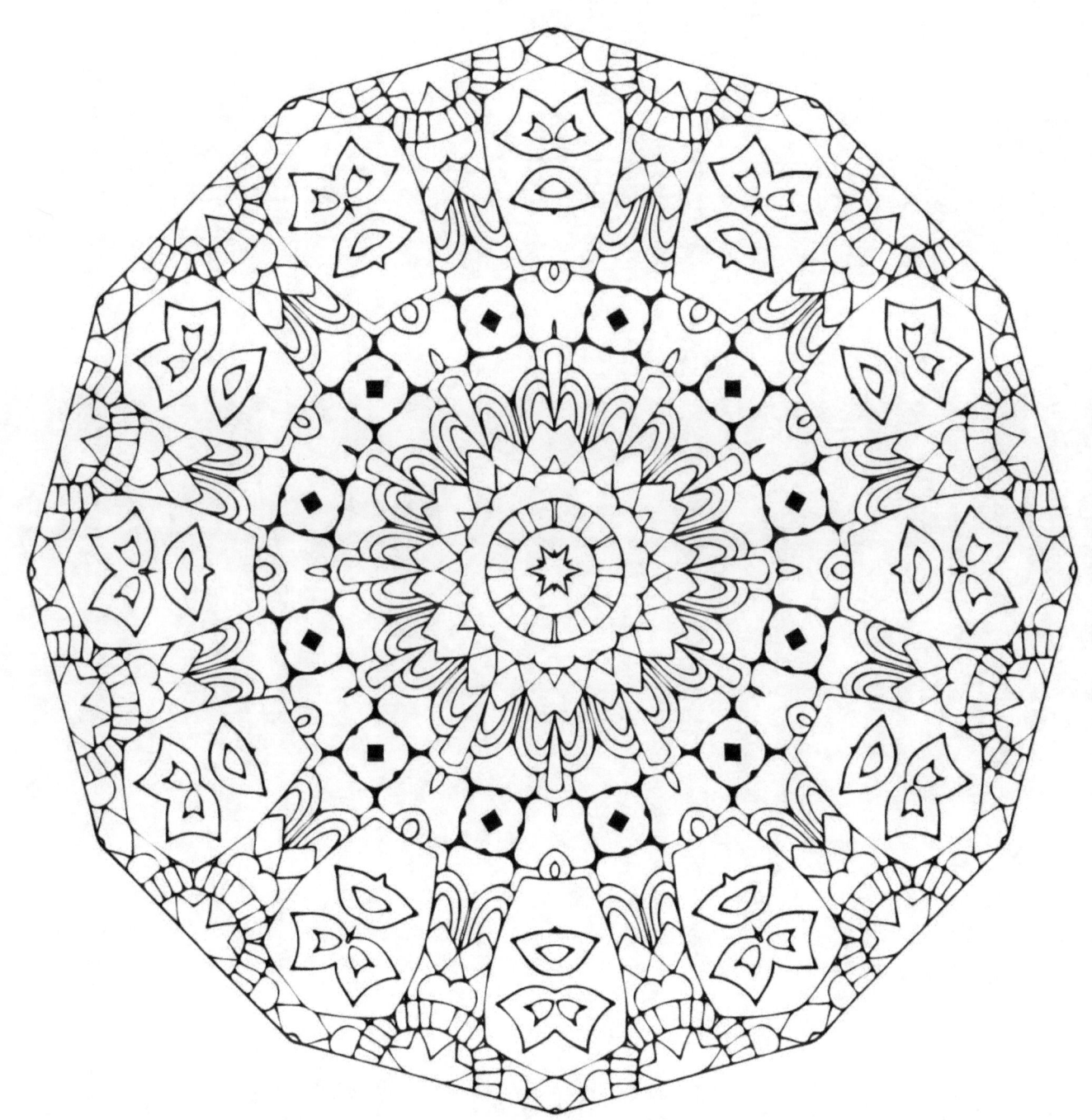

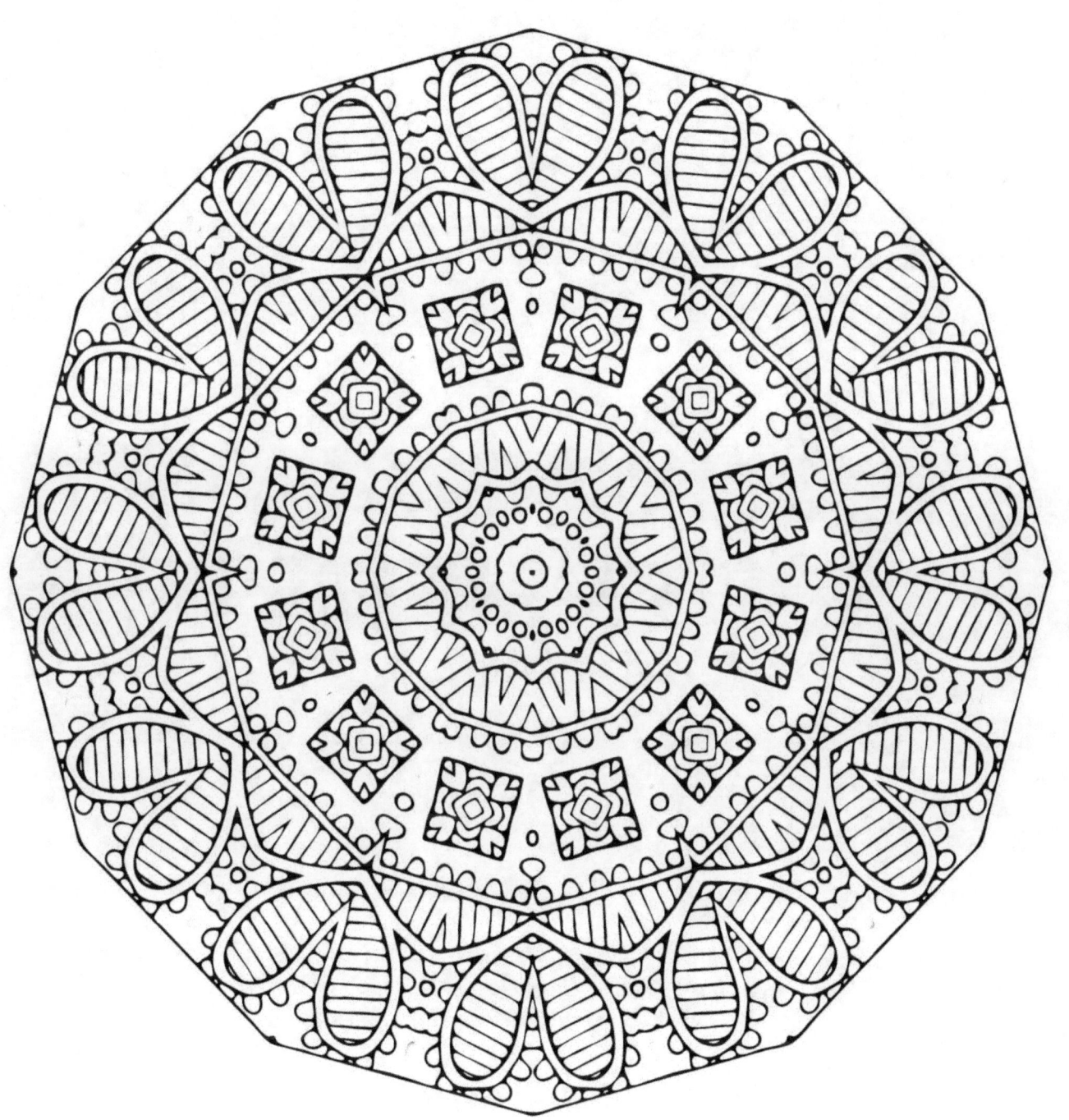

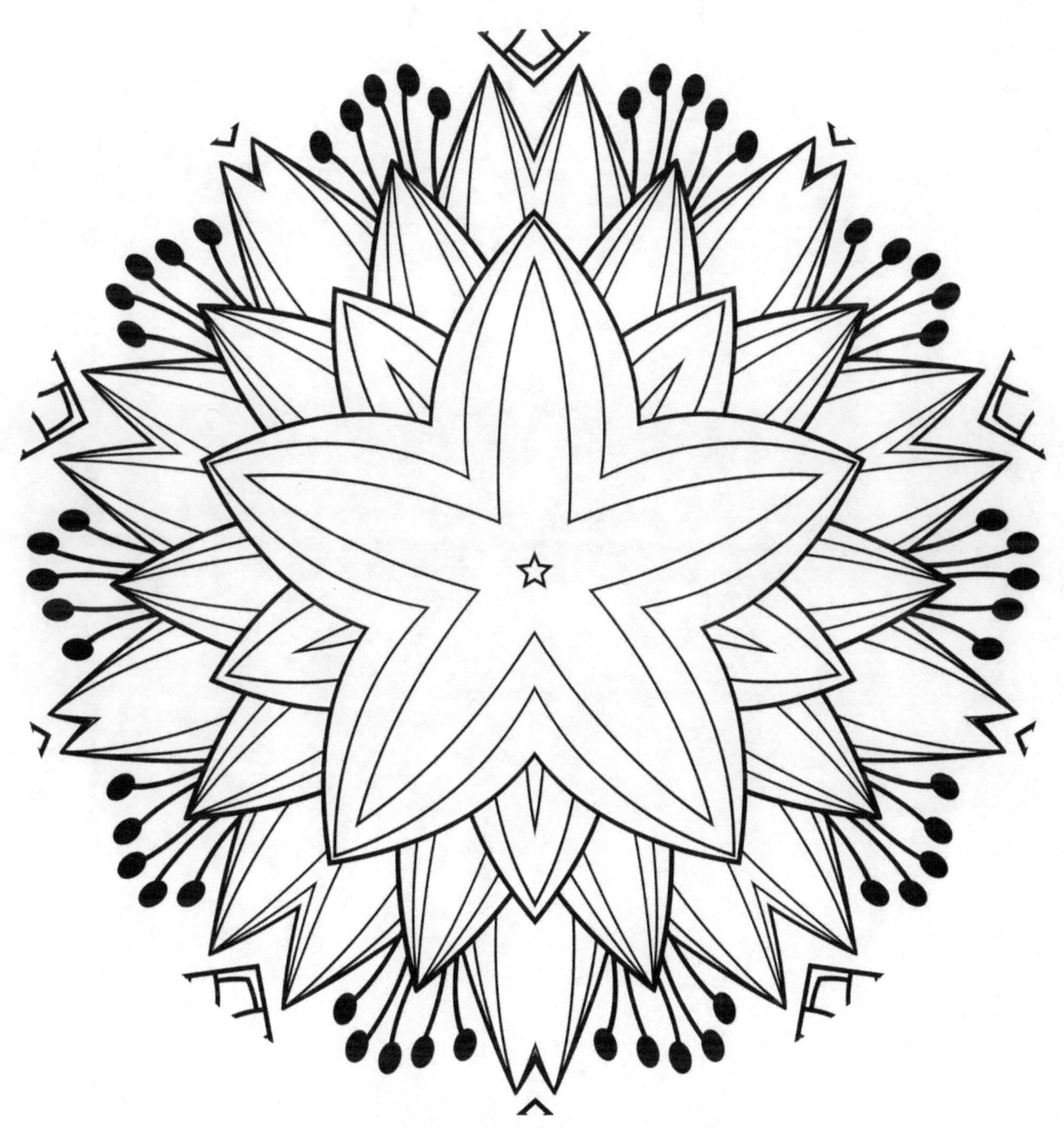

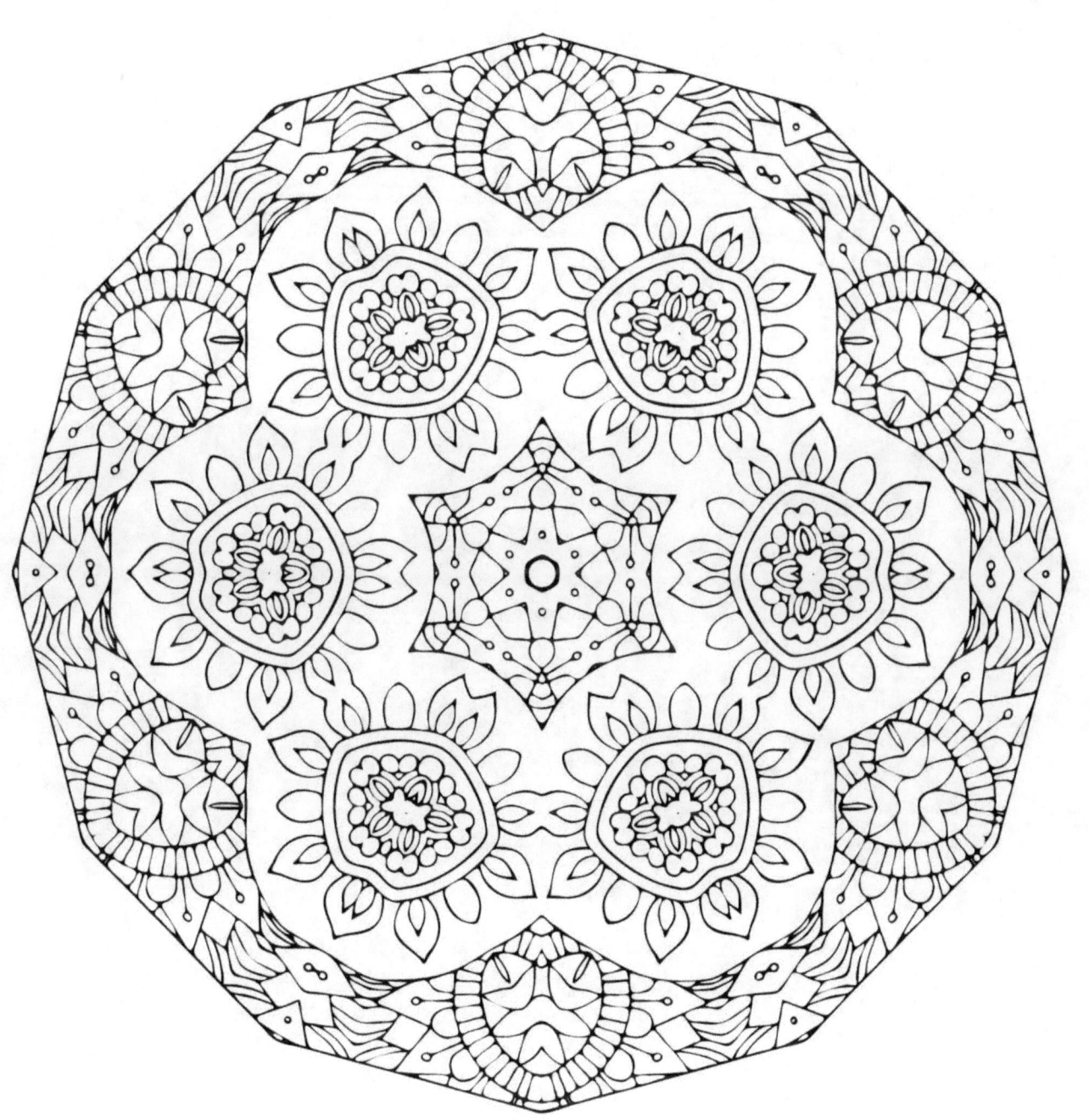

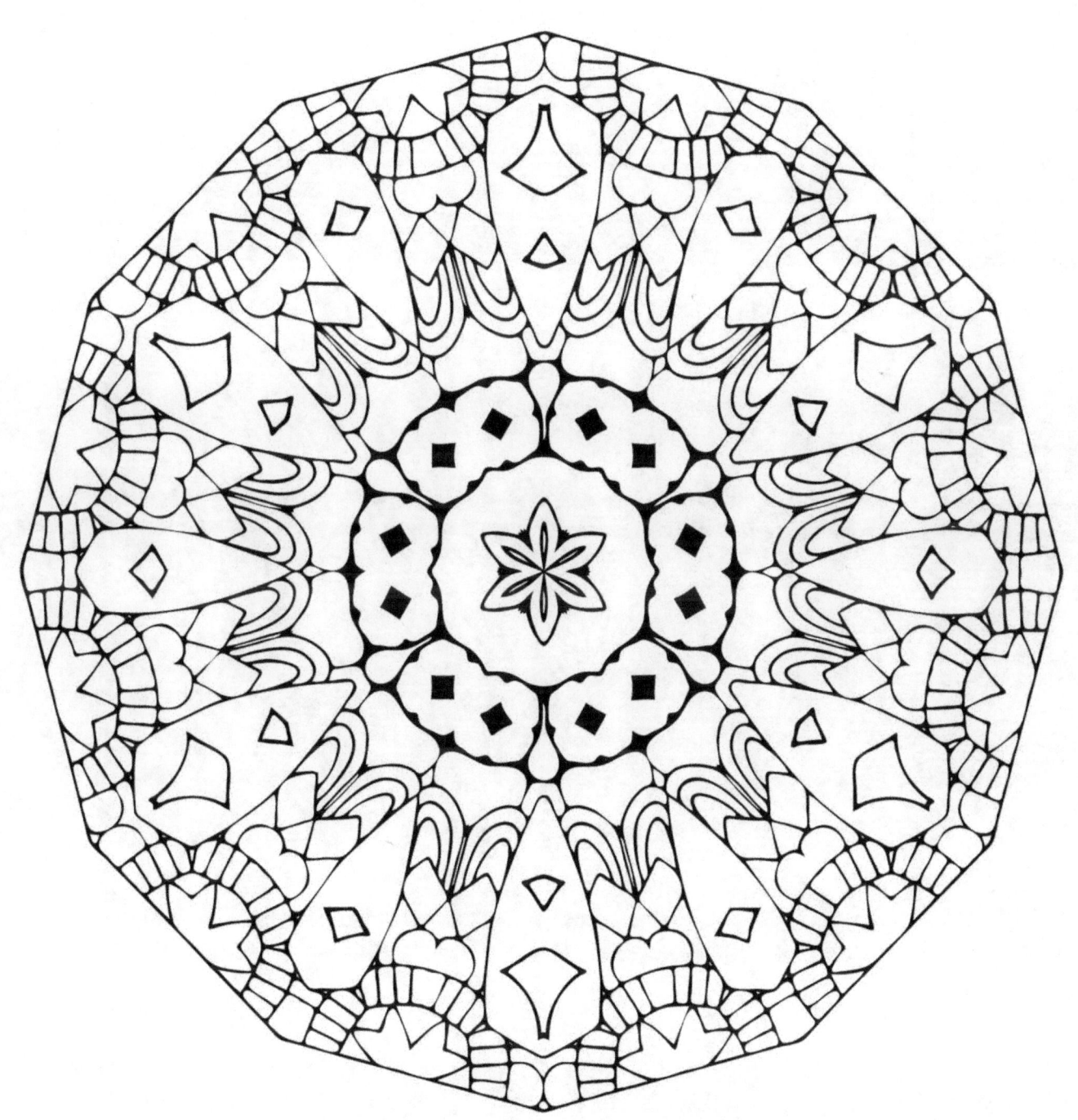

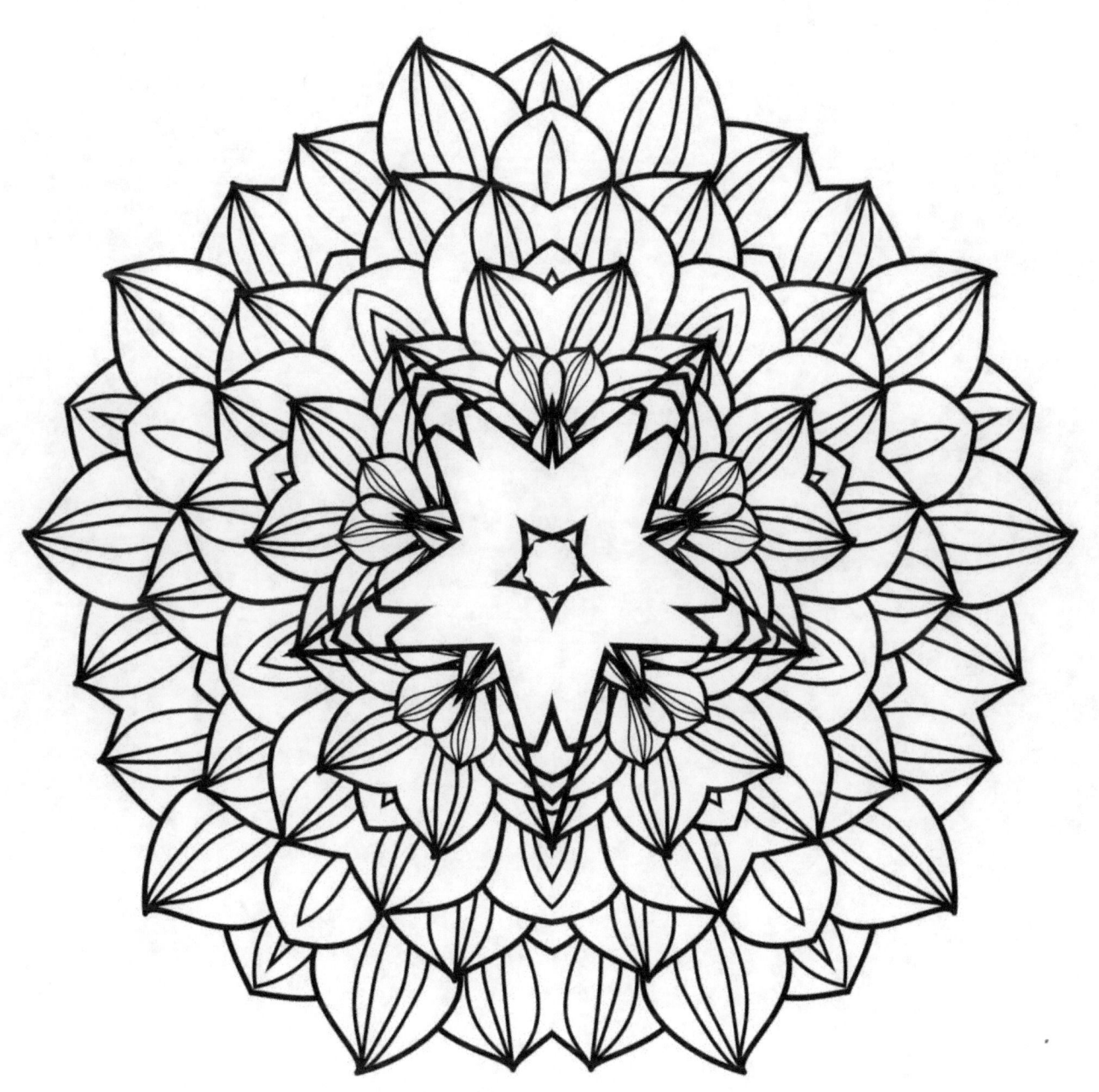

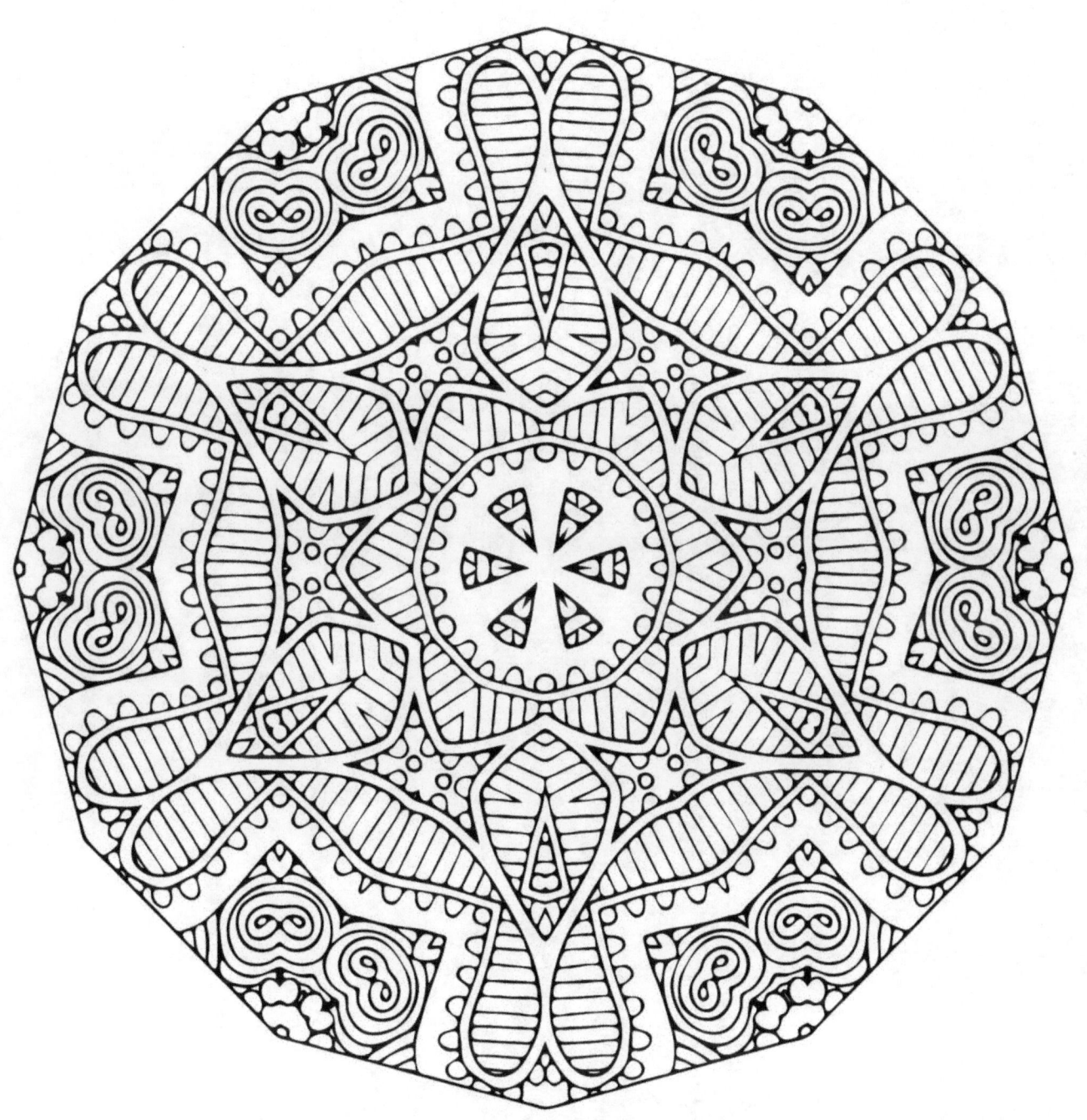

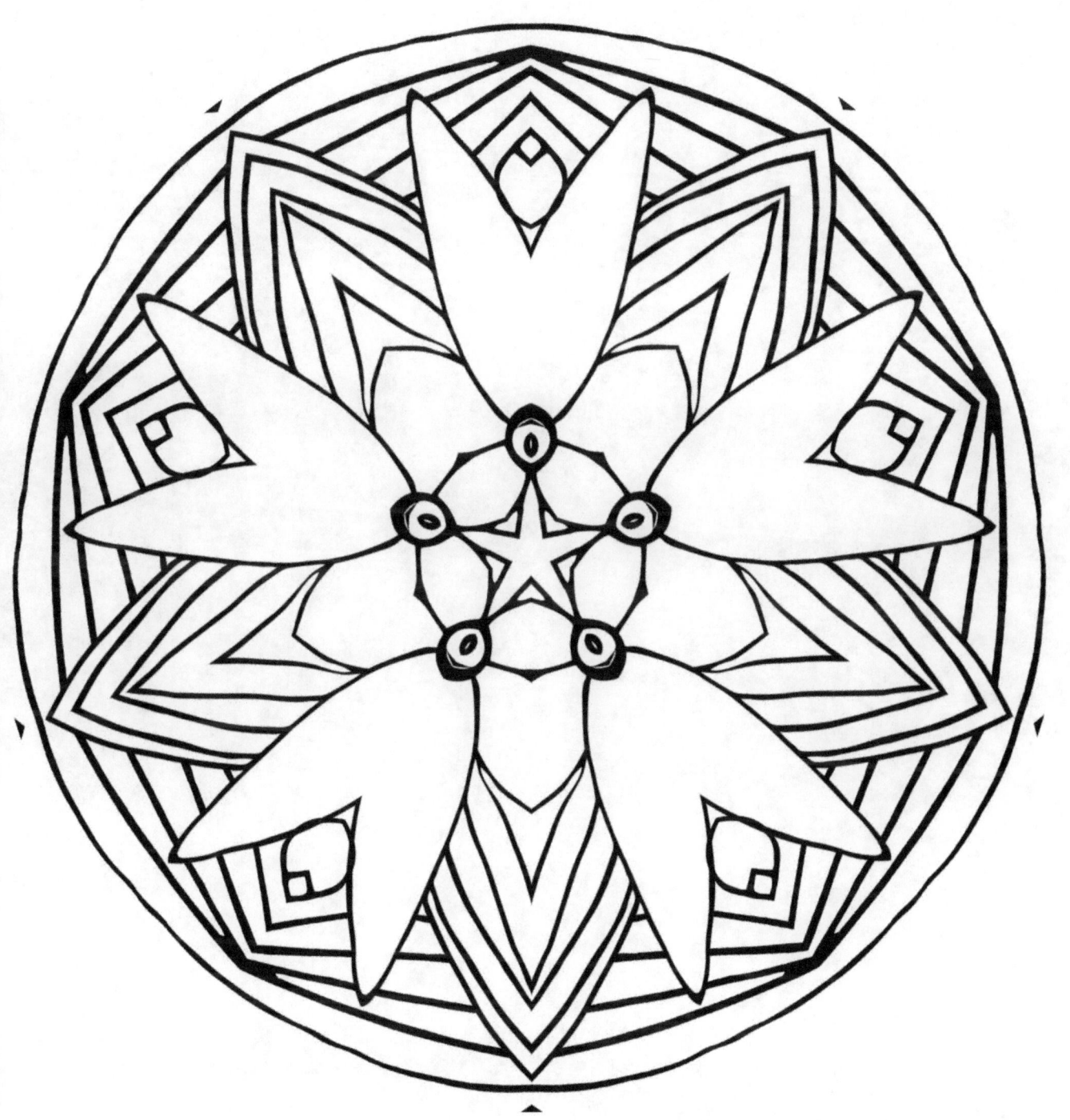

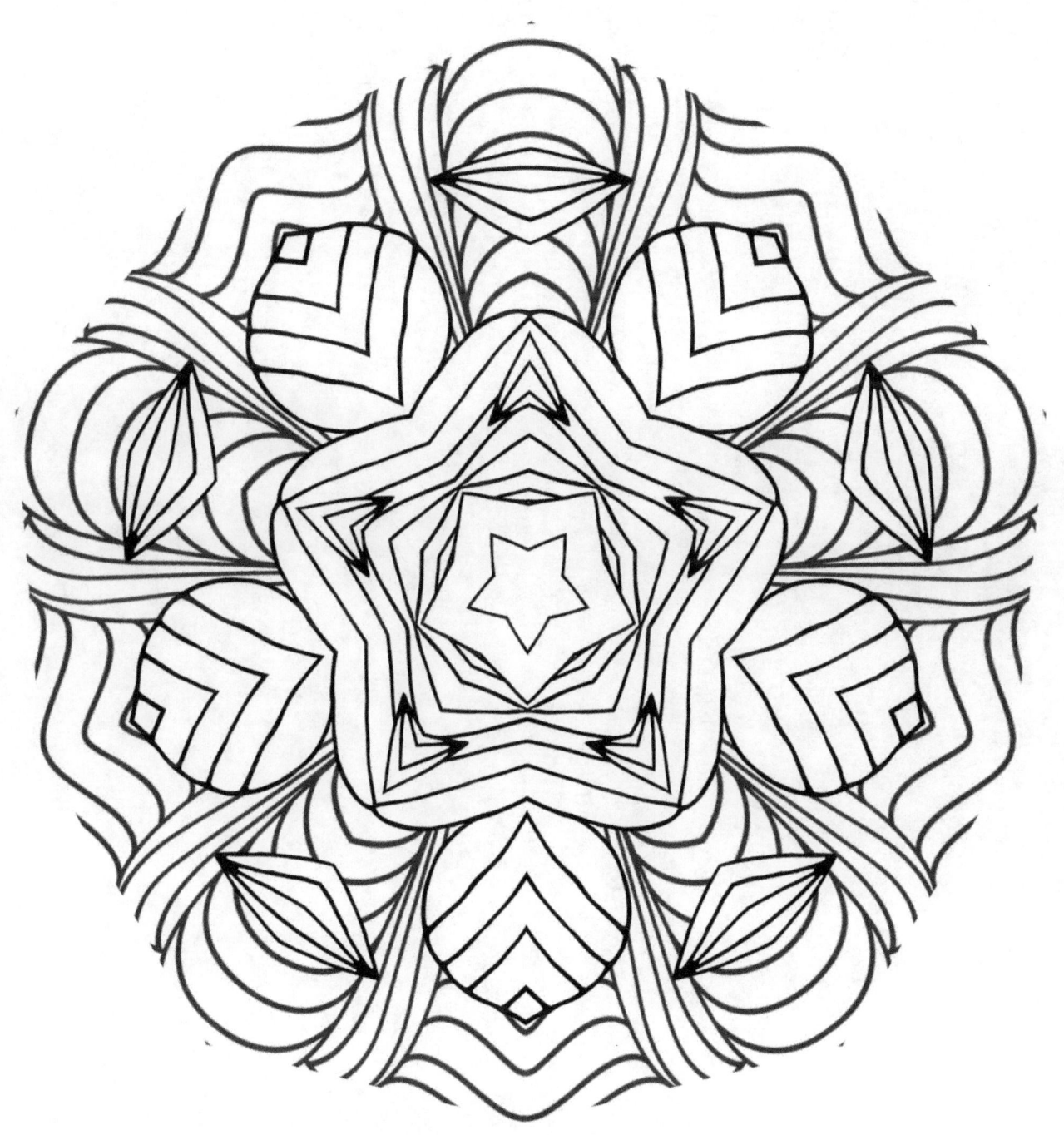

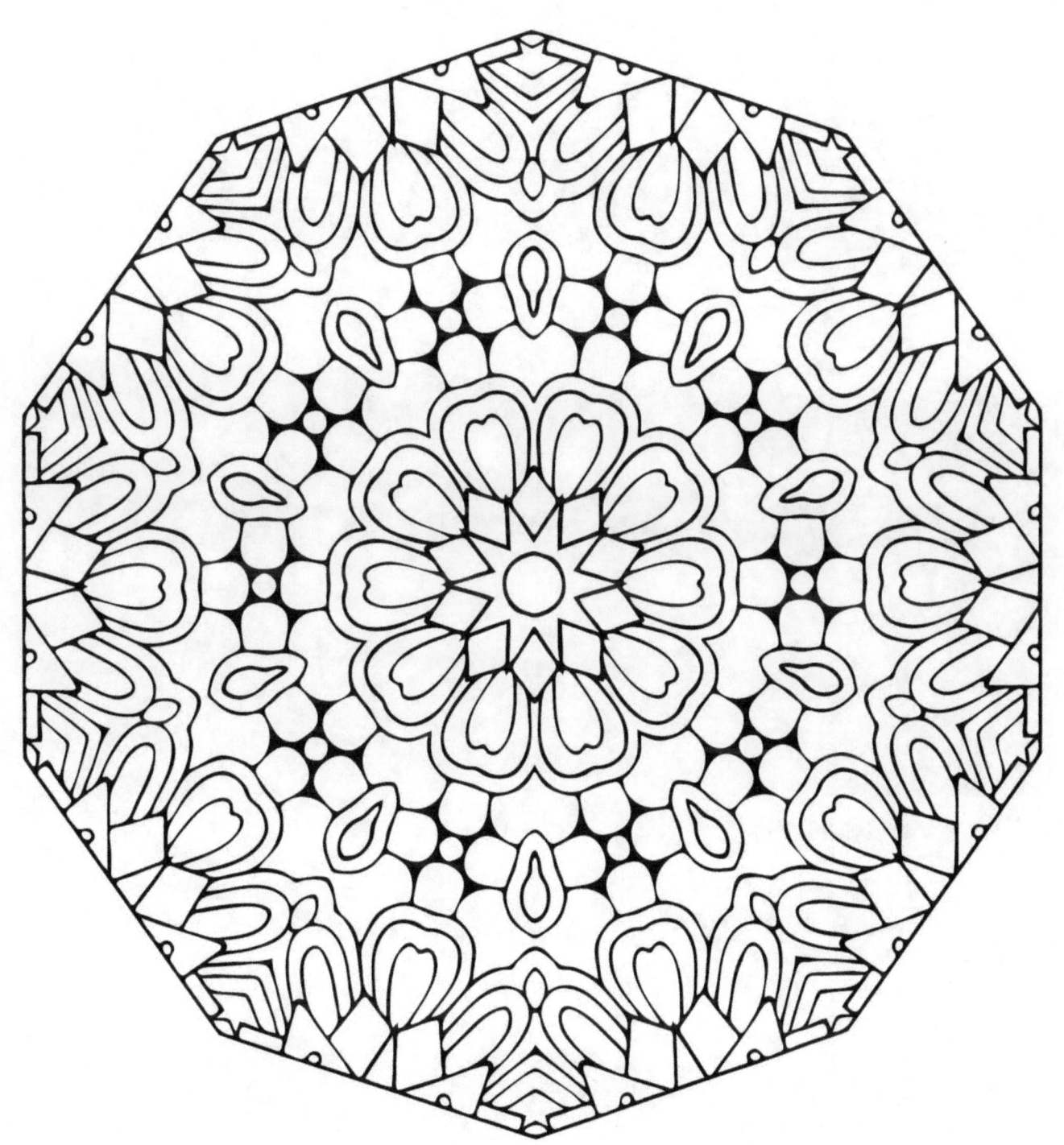

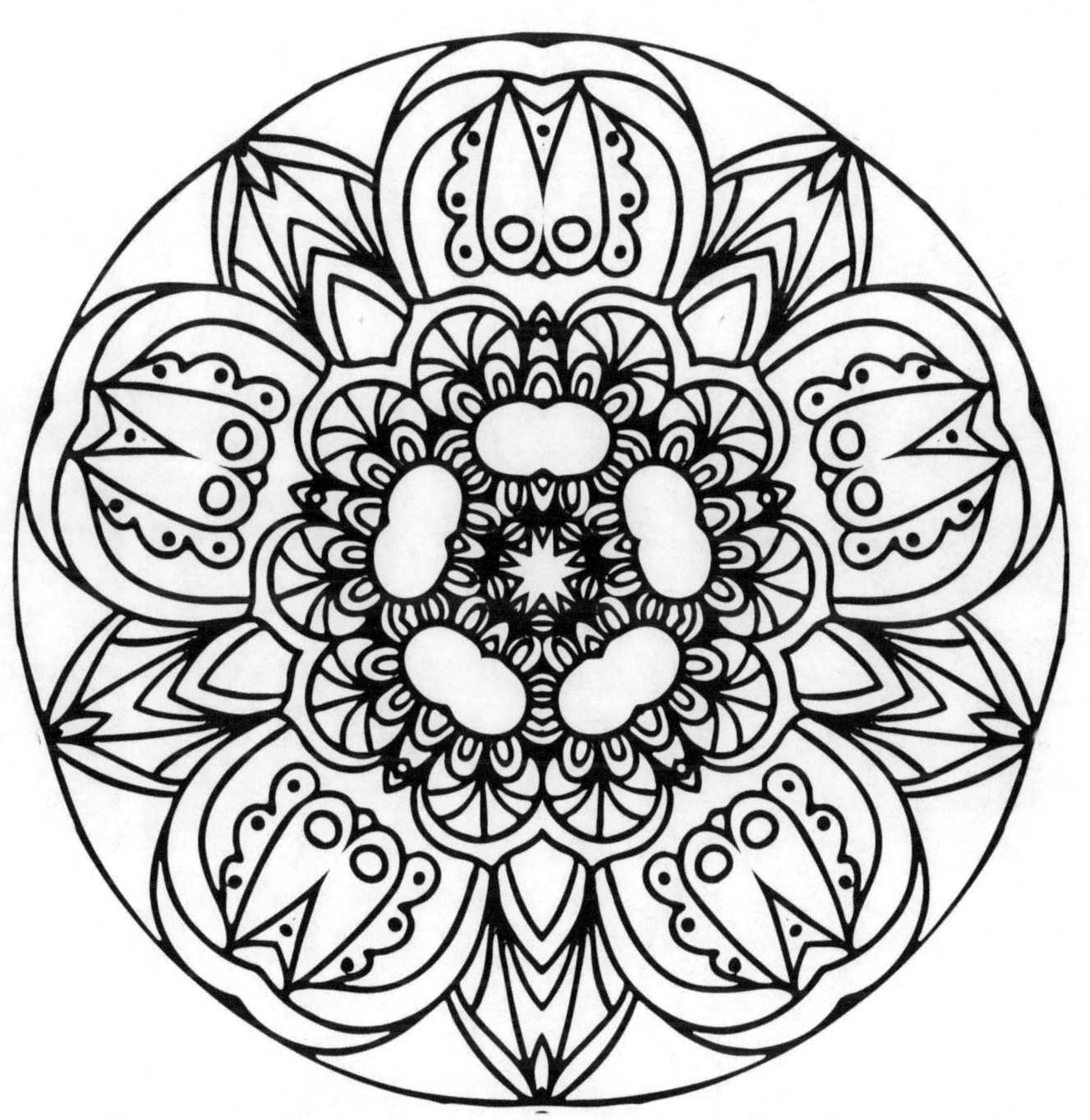

One Last Thing

I hope you have enjoyed colouring the mandalas in this book and that you would be kind enough to consider giving an honest review on Amazon.

Also, look out for the other full sized books in my colouring series where there are many more for you to colour and all available on Amazon.

Please check out my website:

https://charlottegeorgecolouring.com

Best Wishes
Charlotte

www.ingramcontent.com/pod-product-compliance
Lightning Source LLC
Chambersburg PA
CBHW080620190526
45169CB00009B/3249